Art and the Aesthetic

Art and the Aesthetic

AN INSTITUTIONAL ANALYSIS

GEORGE DICKIE

Cornell University Press

ITHACA AND LONDON

First published 1974 by Cornell University Press.
Published in the United Kingdom by Cornell University Press Ltd., 2-4 Brook Street, London W1Y 1AA.

International Standard Book Number 0-8014-0887-3
Library of Congress Catalog Card Number 74-7699

Printed in the United States of America by
York Composition Co., Inc.

For Garrick and Blake

Contents

Contents

Preface

When I first began teaching aesthetics in 1956, I assumed, without having thought about it, that psychical distance, or more generally an aesthetic attitude, is a necessary ingredient of and a foundation for any *aesthetic* appreciation of art or nature. At that time almost all introductory aesthetics texts had an initial chapter which explained the nature of the aesthetic attitude, usually almost entirely by contrasting it with practical attitudes such as the moral, the scientific, and the economic. That there is such an aesthetic attitude is still a widely held view. I began using Monroe Beardsley's *Aesthetics: Problems in the Philosophy of Criticism* for my aesthetics course shortly after it was published in 1958. The account of the field of aesthetics that Beardsley gives in his book in no way depends on the notion of aesthetic attitude; in fact, he simply ignores the topic except for a casual mention and construes aesthetics as metacriticism, that is, as the philosophy of criticism. The significance of Beardsley's omission, that aesthetics does not rely on the

notion of aesthetic attitude, was not apparent to me at first. I had then assumed that there was an aesthetic attitude which was the basis for aesthetic appreciation, but I thought that many of the problems of aesthetics could be discussed independently of it. During this time I attempted to defend Edward Bullough's notion of psychical distance by patching up what I took to be some of its minor faults. About 1961, I used an aesthetic-attitude text for my course and in the middle of the term came to feel, without being able to say why, that the aesthetic-attitude approach was profoundly mistaken. I then began to try to discover what was wrong with the theory. The search first took the form of a deeper criticism of psychical distance, was later broadened to include criticism of other aesthetic-attitude theories, and led finally to an attempt to give an account of aesthetic object which is free of dependence on the conception of aesthetic attitude. This account followed the general metacritical approach of Monroe Beardsley, although I rejected some parts of his theory and developed notions he leaves undeveloped.

In 1967, as a commentator on a paper by Morris Weitz, I began thinking about Weitz's well-known claim that "art" cannot be defined. This endeavor resulted in a short paper on the topic which subsequently went through several stages of development. In working out what I came to call "the institutional definition of 'art,'" I stressed the conventional matrix in which works of art are embedded and which provides the defining characteristics of art. I then realized that the conception of aes-

thetic object which I had worked out earlier is also an institutional concept and came to think that perhaps the institutional concept of art and the institutional concept of aesthetic object might be brought together as related features of a single theory. This book is the attempt to develop such a theory.

Chapter 1 contains my arguments against Weitz's view that "art" cannot be defined and my attempt to define it in institutional terms. Chapters 2 through 7 contain my account of the historical development of the concept of the aesthetic, my arguments against three versions of aesthetic-attitude theory, and my institutional account of aesthetic object. Chapter 8 is a criticism of Monroe Beardsley's theory of aesthetic experience plus some suggestions of my own as to the nature of such experience. This last chapter stands somewhat outside the closely related structure of the first seven, although aesthetic experience is a natural topic once the discussion of aesthetic object is concluded. It may appear odd that only one chapter is devoted to the theory of art and six chapters are devoted to the theory of aesthetic object. This division of space is justified by the fact that, whereas a number of theories of aesthetic object are currently defended, only the "negative" theory of art, that "art" cannot be defined, seems to attract present-day philosophers.

Since this book is an attempt to develop a theory that encompasses both the concept of art and the concept of aesthetic object, I shall try to indicate briefly in what sense my accounts of these two concepts go together, as well as how my accounts contrast with other theories.

The institutional theory of art concentrates attention on the *nonexhibited* characteristics that works of art have in virtue of being embedded in an institutional matrix which may be called "the artworld" and argues that these characteristics are essential and defining. The imitation theory, which is the oldest art theory, contrasts with the institutional view of art in that it stresses the *exhibited* characteristic of representation as essential. The expression theory of art, for another example, contrasts with the institutional view in that, while the expression theory focuses on a *nonexhibited* characteristic, this characteristic derives from a work's relation to its creator rather than from its relation to the wider artworld. The institutional theory of aesthetic object concentrates attention on the practices and conventions used in presenting certain aspects of works of art to their audiences and argues that the presentational conventions locate or isolate the aesthetic objects (features) of works of art. The aesthetic-attitude theorists, by contrast, hold what may be called a "psychologistic" view, arguing that it is an aesthetic state of mind (variously characterized) of a person that locates and makes accessible the aesthetic features of objects. Beardsley's conception of aesthetic object, though somewhat similar to mine, contrasts with the institutional view in that (1) it does not bring out the importance of the conventions of presentation and (2) it attempts to make use of what may be called "epistemological" considerations (the perceptual/physical distinction) to separate aesthetic features of works of art from their non-aesthetic features. The justification for saying that my

definition of "art" and my account of aesthetic object are aspects of a single theory is the claim that both notions essentially involve conventions of presentation. At the end of Chapter 7, I claim that one of these notions is embedded in the other.

Most of the ideas and arguments in this book were initially worked out in a series of articles published over the last eleven years. The core ideas of Chapter 1 were contained in a short article, "Defining Art" (*American Philosophical Quarterly*, July 1969, pp. 253–256). These ideas were developed further in a symposium paper given at Kansas State University in 1970 and subsequently published under the title "The Institutional Conception of Art" in *Language and Aesthetics* (Benjamin R. Tilghman, ed. [Lawrence, Kans.: University Press of Kansas, 1973], pp. 21–30). My ideas on the defining of "art" reached a stage that approximates the form they take in Chapter 1 in "Defining Art II," an article published in an anthology, *Contemporary Aesthetics* (Matthew Lipman, ed. [Boston: Allyn and Bacon, 1973], pp. 118–131). Chapter 2 appeared in substantially its present form as an article entitled "Taste and Attitude: The Origin of the Aesthetic" (*Theoria*, Parts 1–3, 1973, pp. 153–170). My concern with the notion of psychical distance—the topic of Chapter 4—is older than that of any other problem discussed in this book. My earliest attack on the theory of psychical distance occurred in the latter part of "Is Psychology Relevant to Aesthetics?" (*Philosophical Review*, July 1962, pp. 297–300). I discussed psychical distance

again briefly in "The Myth of the Aesthetic Attitude" (*American Philosophical Quarterly*, January 1964, pp. 56–64). More recently I have defended my position in a brief article, "Bullough and Casebier: Disappearing in the Distance" (*The Personalist*, Spring 1972, pp. 127–131), but Chapter 4 is my first full-scale treatment of psychical distance. It was recently published as "Psychical Distance: In a Fog at Sea" in the *British Journal of Aesthetics* (Winter 1973, pp. 17–29). The ideas concerning aesthetic attention set forth in Chapter 5 were first worked out in the long middle section of "The Myth of the Aesthetic Attitude." The ideas concerning Virgil Aldrich's notion of aesthetic perception developed in Chapter 6 were first worked out in "Attitude and Object: Aldrich on the Aesthetic" (*Journal of Aesthetics and Art Criticism*, Fall 1966, pp. 89–91). The basis for my discussion of the notion of aesthetic object in Chapter 7 was laid down in "Art Narrowly and Broadly Speaking" (*American Philosophical Quarterly*, January 1968, pp. 71–77), but the treatment in the book is much more extensive. I first criticized Monroe Beardsley's theory of aesthetic experience in "Beardsley's Phantom Aesthetic Experience" (*Journal of Philosophy*, March 4, 1965, pp. 129–136). My arguments against Beardsley's theory, however, have been substantially revised in the discussion in Chapter 8. This revised treatment was published under the title "Beardsley's Theory of Aesthetic Experience" (*Journal of Aesthetic Education*, April 1974, pp. 13–23). The ideas developed in Chapter 3 have not been previously presented in published form;

this material is designed to provide a transition from the historical discussion in Chapter 2 to my analyses of the present-day theories of aesthetic attitude and aesthetic object in the chapters that follow. Summary accounts of many of the topics discussed in this book are contained in my recently published *Aesthetics: An Introduction* (Indianapolis, 1971), including a definition of "art" (pp. 95–108), the history of the concept of the aesthetic (pp. 9–32), theories of aesthetic attitude (pp. 47–60), and the notion of aesthetic object (pp. 61–68).

Many people have helped by reading and criticizing early versions of chapters. Monroe Beardsley of Temple University read all chapters of the book and in several instances read more than one version of the same chapter. His comments and encouragement have been of greatest value. Beardsley's books and articles on aesthetics have been a continuing source of inspiration and stimulation to me, as readers will discover from the numerous discussions of Beardsley's ideas contained in this book. William Hayes of Stanislaus State College, W. E. Kennick of Amherst College, and Richard Sclafani of Rice University also read the entire manuscript and made valuable comments which improved every chapter. Arthur Danto of Columbia University, Kendall Walton of the University of Michigan, Ralf Meerbote of the University of Illinois at Chicago Circle, and Terry Diffey of the University of Sussex read Chapter 1 and made many helpful recommendations for its improvement. Walter Hipple of Indiana State University, Elmer Duncan of Baylor University, and Ralf Meerbote read Chap-

ter 2 and prevented me from making several errors on historical matters. Allan Casebier of the University of Southern California provided me with useful advice on Chapter 4. Terry Diffey also read Chapter 7 and made many encouraging and valuable comments. I wish to thank Ruth Marcus for her insights on Chapter 1, for her earlier help with "Art Narrowly and Broadly Speaking," and for her encouragement. My wife, Joyce, has been of enormous help in editing the manuscript of this book.

The time to write this book was made possible by a sabbatical leave granted by the University of Illinois at Chicago Circle and by a National Endowment for the Humanities Senior Fellowship.

GEORGE DICKIE

Evanston, Illinois

Art and the Aesthetic

1

What Is Art?:
An Institutional Analysis

The attempt to define "art" by specifying its necessary and sufficient conditions is an old endeavor. The first definition—the imitation theory—despite what now seem like obvious difficulties, more or less satisfied everyone until some time in the nineteenth century. After the expression theory of art broke the domination of the imitation theory, many definitions purporting to reveal the necessary and sufficient conditions of art appeared. In the mid-1950's, several philosophers, inspired by Wittgenstein's talk about concepts, began arguing that there are no necessary and sufficient conditions for art. Until recently, this argument had persuaded so many philosophers of the futility of trying to define art that the flow of definitions had all but ceased. Although I will ultimately try to show that "art" can be defined, the denial of that possibility has had the very great value of forcing us to look deeper into the concept of "art." The parade of dreary and superficial definitions that had been presented was, for a variety of reasons, eminently rejectable.

The traditional attempts to define "art," from the imitation theory on, may be thought of as Phase I and the contention that "art" cannot be defined as Phase II. I want to supply Phase III by defining "art" in such a way as to avoid the difficulties of the traditional definitions and to incorporate the insights of the later analysis. I should note that the imitation theory of the fine arts seems to have been adopted by those who held it without much serious thought and perhaps cannot be considered as a self-conscious theory of art in the way that the later theories can be.

The traditional attempts at definition have sometimes failed to see beyond prominent but accidental features of works of art, features that have characterized art at a particular stage in its historical development. For example, until quite recently the works of art clearly recognizable as such were either obviously representational or assumed to be representational. Paintings and sculptures were obviously so, and music was widely assumed in some sense also to be representational. Literature was representational in that it described familiar scenes of life. It was, then, easy enough to think that imitation must be the essence of art. The imitation theory focused on a readily evident relational property of works of art, namely, art's relation to subject matter. The development of nonobjective art showed that imitation is not even an always-accompanying property of art, much less an essential one.

The theory of art as the expression of emotion has focused on another relational property of works of art, the relation of a work to its creator. The expression

theory also has proved inadequate, and no other subsequent definition has been satisfactory. Although not fully satisfying as definitions, the imitation and expression theories do provide a clue: both singled out *relational* properties of art as essential. As I shall try to show, the two defining characteristics of art are indeed relational properties, and one of them turns out to be exceedingly complex.

I

The best-known denial that "art" can be defined occurs in Morris Weitz's article "The Role of Theory in Aesthetics."[1] Weitz's conclusion depends upon two arguments which may be called his "generalization argument" and his "classification argument." In stating the "generalization argument" Weitz distinguishes, quite correctly, between the generic conception of "art" and the various subconcepts of art such as tragedy, the novel, painting, and the like. He then goes on to give an argument purporting to show that the subconcept "novel" is open, that is, that the members of the class of novels do not share any essential or defining characteristics. He then asserts without further argument that what is true of novels is true of all other subconcepts of art. The generalization from one subconcept to all subconcepts may or may not

[1] *Journal of Aesthetics and Art Criticism*, September 1956, pp. 27–35. See also Paul Ziff's "The Task of Defining a Work of Art," *Philosophical Review*, January 1953, pp. 58–78; and W. E. Kennick's "Does Traditional Aesthetics Rest on a Mistake?" *Mind*, July 1958, pp. 317–334.

be justified, but I am not questioning it here. I do question, however, Weitz's additional contention, also asserted without argument, that the generic conception of "art" is open. The best that can be said of his conclusion about the generic sense is that it is unsupported. All or some of the subconcepts of art may be open and the generic conception of art still be closed. That is, it is possible that all or some of the subconcepts of art, such as novel, tragedy, sculpture, and painting, may lack necessary and sufficient conditions and at the same time that "work of art," which is the genus of all the subconcepts, can be defined in terms of necessary and sufficient conditions. Tragedies may not have any characteristics in common which would distinguish them from, say, comedies *within the domain of art*, but it may be that there are common characteristics that works of art have which distinguish them from nonart. Nothing prevents a "closed genus/open species" relationship. Weitz himself has recently cited what he takes to be a similar (although reversed) example of genus-species relationship. He argues that "game" (the genus) is open but that "major league baseball" (a species) is closed.[2]

His second argument, "the classification argument," claims to show that not even the characteristic of artifactuality is a necessary feature of art. Weitz's conclusion

[2] "Wittgenstein's Aesthetics," in *Language and Aesthetics*, Benjamin R. Tilghman, ed. (Lawrence, Kans., 1973), p. 14. This paper was read at a symposium at Kansas State University in April 1970. Monroe Beardsley has pointed out to me that the relationship between "game" and "major league baseball" is one of class and member rather than of genus and species.

here is something of a surprise, because it has been widely assumed by philosophers and nonphilosophers alike that a work of art is necessarily an artifact. His argument is simply that we sometimes utter such statements as "This piece of driftwood is a lovely piece of sculpture," and since such utterances are perfectly intelligible, it follows that some nonartifacts such as certain pieces of driftwood are works of art (sculptures). In other words, something need not be an artifact in order to be correctly classified as a work of art. I will try to rebut this argument shortly.

Recently, Maurice Mandelbaum has raised a question about Wittgenstein's famous contention that "game" cannot be defined and Weitz's thesis about "art."[3] His challenge to both is based on the charge that they have been concerned only with what Mandelbaum calls "exhibited" characteristics and that consequently each has failed to take account of the nonexhibited, relational aspects of games and art. By "exhibited" characteristics Mandelbaum means easily perceived properties such as the fact that a ball is used in a certain kind of game, that a painting has a triangular composition, that an area in a painting is red, or that the plot of a tragedy contains a reversal of fortune. Mandelbaum concludes that when we consider the nonexhibited properties of games, we see that they have in common "the potentiality of . . . [an] . . . absorbing non-practical interest to either partici-

[3] "Family Resemblances and Generalizations Concerning the Arts," *American Philosophical Quarterly*, July 1965, pp. 219–228; reprinted in *Problems in Aesthetics*, Morris Weitz, ed., 2d ed. (London, 1970), pp. 181–197.

pants or spectators."[4] Mandelbaum may or may not be right about "game," but what interests me is the application of his suggestion about nonexhibited properties to the discussion of the definition of art. Although he does not attempt a definition of "art," Mandelbaum does suggest that feature(s) common to all works of art may perhaps be discovered that will be a basis for the definition of "art," if the nonexhibited features of art are attended to.

Having noted Mandelbaum's invaluable suggestion about definition, I now return to Weitz's argument concerning artifactuality. In an earlier attempt to show Weitz wrong, I thought it sufficient to point out that there are two sense of "work of art," an evaluative sense and a classificatory one; Weitz himself distinguishes these in his article as the evaluative and the descriptive senses of art. My earlier argument was that if there is more than one sense of "work of art," then the fact that "This piece of driftwood is a lovely piece of sculpture" is intelligible does not prove what Weitz wants it to prove. Weitz would have to show that "sculpture" is being used in the sentence in question in the classificatory sense, and this he makes no attempt to do. My argument assumed that once the distinction is made, it is obvious that "sculpture" is here being used in the evaluative sense. Richard Sclafani has subsequently noted that my argument shows only that Weitz's argument is inconclusive and that Weitz might still be right, even though his argument does

[4] *Ibid.*, p. 185 in the Weitz anthology.

not prove his conclusion. Sclafani, however, has constructed a stronger argument against Weitz on this point.[5]

Sclafani shows that there is a third sense of "work of art" and that "driftwood cases" (the nonartifact cases) fall under it. He begins by comparing a paradigm work of art, Brancusi's *Bird in Space,* with a piece of driftwood which looks very much like it. Sclafani says that it seems natural to say of the piece of driftwood that it is a work of art and that we do so because it has so many properties in common with the Brancusi piece. He then asks us to reflect on our characterization of the driftwood and the *direction* it has taken. We say the driftwood is art because of its resemblance to some paradigm work of art or because the driftwood shares properties with several paradigm works of art. The paradigm work or works are of course always artifacts; the direction of our move is from paradigmatic (artifactual) works of art to nonartifactual "art." Sclafani quite correctly takes this to indicate that there is a primary, paradigmatic sense of "work of art" (my classificatory sense) and a derivative or secondary sense into which the "driftwood cases" fall. Weitz is right in a way in saying that the driftwood is art, but wrong in concluding that artifactuality is unnecessary for (the primary sense of) art.

There are then at least three distinct senses of "work of art": the primary or classificatory sense, the secondary or derivative, and the evaluative. Perhaps in most uses of Weitz's driftwood sentence example, both the derivative

[5] " 'Art' and Artifactuality," *Southwestern Journal of Philosophy,* Fall 1970, pp. 105–108.

and the evaluative senses would be involved: the derivative sense if the driftwood shared a number of properties with some paradigm work of art and the evaluative sense if the shared properties were found to be valuable by the speaker. Sclafani gives a case in which only the evaluative sense functions, when someone says, "Sally's cake is a work of art." In most uses of such a sentence "work of art" would simply mean that its referent has valuable qualities. Admittedly, one can imagine contexts in which the derivative sense would apply to cakes. (Given the situation in art today, one can easily imagine cakes to which the primary sense of art could be applied.) If, however, someone were to say, "This Rembrandt is a work of art," both the classificatory and the evaluative senses would be functioning. The expression "this Rembrandt" would convey the information that its referent is a work of art in the classificatory sense, and "is a work of art" could then only reasonably be understood in the evaluative sense. Finally, someone might say of a sea shell or other natural object which resembles a man's face but is otherwise uninteresting, "This shell (or other natural object) is a work of art." In this case, only the derivative sense would be used.

We utter sentences in which the expression "work of art" has the evaluative sense with considerable frequency, applying it to both natural objects and artifacts. We speak of works of art in the derived sense with somewhat less frequency. The classificatory sense of "work of art," which indicates simply that a thing belongs to a certain category of artifacts, occurs, however, very infrequently

in our discourse. We rarely utter sentences in which we use the classificatory sense, because it is such a basic notion: we generally know immediately whether an object is a work of art, so that generally no one needs to say, by way of classification, "That is a work of art," although recent developments in art such as junk sculpture and found art may occasionally force such remarks. Even if we do not often talk about art in this classificatory sense, however, it is a basic concept that structures and guides our thinking about our world and its contents.

II

It is now clear that artifactuality is a necessary condition (call it the genus) of the primary sense of art. This fact, however, does not seem very surprising and would not even be very interesting except that Weitz and others have denied it. Artifactuality alone, however, is not the whole story and another necessary condition (the differentia) has to be specified in order to have a satisfactory definition of "art." Like artifactuality, the second condition is a nonexhibited property, which turns out to be as complicated as artifactuality is simple. The attempt to discover and specify the second condition of art will involve an examination of the intricate complexities of the "artworld." W. E. Kennick, defending a view similar to Weitz's, contends that the kind of approach to be employed here, following Mandelbaum's lead, is futile. He concludes that "the attempt to define Art in terms of what we do with certain objects is as doomed as any

other."[6] He tries to support this conclusion by referring to such things as the fact that the ancient Egyptians sealed up paintings and sculptures in tombs. There are two difficulties with Kennick's argument. First, that the Egyptians sealed up paintings and sculptures in tombs does not show that they regarded them differently from the way in which we regard them. They might have put them there for the dead to appreciate or simply because they belonged to the dead person. The Egyptian practice does not establish so radical a difference between their conception of art and ours that a definition subsuming both is impossible. Second, one need not assume that we and the ancient Egyptians share a common conception of art. It would be enough to be able to specify the necessary and sufficient conditions for the concept of art which we have (we present-day Americans, we present-day Westerners, we Westerners since the organization of the system of the arts in or about the eighteenth century —I am not sure of the exact limits of the "we"). Kennick notwithstanding, we are most likely to discover the differentia of art by considering "what we do with certain objects." Of course, nothing guarantees that any given thing we might do or an ancient Egyptian might have done with a work of art will throw light on the concept of art. Not every "doing" will reveal what is required.

Although he does not attempt to formulate a definition, Arthur Danto in his provocative article, "The Art-

[6] "Does Traditional Aesthetics Rest on a Mistake?" p. 330.

world," has suggested the direction that must be taken by an attempt to define "art."[7] In reflecting on art and its history together with such present-day developments as Warhol's *Brillo Carton* and Rauschenberg's *Bed*, Danto writes, "To see something as art requires something the eye cannot descry—an atmosphere of artistic theory, a knowledge of history of art: an artworld."[8] Admittedly, this stimulating comment is in need of elucidation, but it is clear that in speaking of "something the eye cannot descry" Danto is agreeing with Mandelbaum that nonexhibited properties are of great importance in constituting something as art. In speaking of atmosphere and history, however, Danto's remark carries us a step further than Mandelbaum's analysis. Danto points to the rich structure in which particular works of art are embedded: he indicates *the institutional nature of art*.[9]

I shall use Danto's term "artworld" to refer to the broad social institution in which works of art have their place.[10] But is there such an institution? George Bernard

[7] *Journal of Philosophy*, October 15, 1964, pp. 571–584.

[8] *Ibid.*, p. 580.

[9] Danto does not develop an institutional account of art in his article nor in a subsequent related article entitled "Art Works and Real Things," *Theoria*, Parts 1–3, 1973, pp. 1–17. In both articles Danto's primary concern is to discuss what he calls the Imitation Theory and the Real Theory of Art. Many of the things he says in these two articles are consistent with and can be incorporated into an institutional account, and his brief remarks in the later article about the ascriptivity of art are similar to the institutional theory. The institutional theory is one possible version of the ascriptivity theory.

[10] This remark is not intended as a definition of the term

Shaw speaks somewhere of the apostolic line of succession stretching from Aeschylus to himself. Shaw was no doubt speaking for effect and to draw attention to himself, as he often did, but there is an important truth implied by his remark. There is a long tradition or continuing institution of the theater having its origins in ancient Greek religion and other Greek institutions. That tradition has run very thin at times and perhaps even ceased to exist altogether during some periods, only to be reborn out of its memory and the need for art. The institutions associated with the theater have varied from time to time: in the beginning it was Greek religion and the Greek state; in medieval times, the church; more recently, private business and the state (national theater). What has remained constant with its own identity throughout its history is the theater itself as an established way of doing and behaving, what I shall call in Chapter 7 the primary convention of the theater. This institutionalized behavior occurs on both sides of the "footlights": both the players and the audience are involved and go to make up the institution of the theater. The roles of the actors and the audience are defined by the traditions of the theater. What the author, management, and players present is art, and it is art because it is presented within the theater-world framework. Plays are written to have a place in the theater system and they exist as plays, that is, as art, within that system. Of course, I do not wish to deny that

"artworld," I am merely indicating what the expression is used to *refer* to. "Artworld" is nowhere defined in this book, although the referent of the expression is described in some detail.

plays also exist as literary works, that is, as art within the literary system: the theater system and the literary system overlap. Let me make clear what I mean by speaking of the artworld as an institution. Among the meanings of "institution" in *Webster's New Collegiate Dictionary* are the following: "3. That which is instituted as: a. An established practice, law, custom, etc. b. An established society or corporation." When I call the artworld an institution I am saying that it is an established practice. Some persons have thought that an institution must be an established society or corporation and, consequently, have misunderstood my claim about the artworld.

Theater is only one of the systems within the artworld. Each of the systems has had its own origins and historical development. We have some information about the later stages of these developments, but we have to guess about the origins of the basic art systems. I suppose that we have complete knowledge of certain recently developed subsystems or genres such as Dada and happenings. Even if our knowledge is not as complete as we wish it were, however, we do have substantial information about the systems of the artworld as they currently exist and as they have existed for some time. One central feature all of the systems have in common is that each is a framework for the *presenting* of particular works of art. Given the great variety of the systems of the artworld it is not surprising that works of art have no exhibited properties in common. If, however, we step back and view the works in their institutional setting, we will be able to see the essential properties they share.

Theater is a rich and instructive illustration of the institutional nature of art. But it is a development within the domain of painting and sculpture—Dadaism—that most easily reveals the institutional essence of art. Duchamp and friends conferred the status of art on "readymades" (urinals, hatracks, snow shovels, and the like), and when we reflect on their deeds we can take note of a kind of human action which has until now gone unnoticed and unappreciated—the action of conferring the status of art. Painters and sculptors, of course, have been engaging all along in the action of conferring this status on the objects they create. As long, however, as the created objects were conventional, given the paradigms of the times, the objects themselves and their fascinating exhibited properties were the focus of the attention of not only spectators and critics but of philosophers of art as well. When an artist of an earlier era painted a picture, he did some or all of a number of things: depicted a human being, portrayed a certain man, fulfilled a commission, worked at his livelihood, and so on. In addition he also acted as an agent of the artworld and conferred the status of art on his creation. Philosophers of art attended to only some of the properties the created object acquired from these various actions, for example, to the representational or to the expressive features of the objects. They entirely ignored the nonexhibited property of status. When, however, the objects are bizarre, as those of the Dadaists are, our attention is forced away from the objects' obvious properties to a consideration of the objects in their social context. As works of art Duchamp's

"ready-mades" may not be worth much, but as examples of art they are very valuable for art theory. I am not claiming that Duchamp and friends invented the conferring of the status of art; they simply used an existing institutional device in an unusual way. Duchamp did not invent the artworld, because it was there all along.

The artworld consists of a bundle of systems: theater, painting, sculpture, literature, music, and so on, each of which furnishes an institutional background for the conferring of the status on objects within its domain. No limit can be placed on the number of systems that can be brought under the generic conception of art, and each of the major systems contains further subsystems. These features of the artworld provide the elasticity whereby creativity of even the most radical sort can be accommodated. A whole new system comparable to the theater, for example, could be added in one fell swoop. What is more likely is that a new subsystem would be added within a system. For example, junk sculpture added within sculpture, happenings added within theater. Such additions might in time develop into full-blown systems. Thus, the radical creativity, adventuresomeness, and exuberance of art of which Weitz speaks is possible within the concept of art, even though it is closed by the necessary and sufficient conditions of artifactuality and conferred status.

Having now briefly described the artworld, I am in a position to specify a definition of "work of art." The definition will be given in terms of artifactuality and the conferred status of art or, more strictly speaking, the con-

ferred status of candidate for appreciation. Once the definition has been stated, a great deal will still remain to be said by way of clarification: A work of art in the classificatory sense is (1) an artifact (2) a set of the aspects of which has had conferred upon it the status of candidate for appreciation by some person or persons acting on behalf of a certain social institution (the artworld).

The second condition of the definition makes use of four variously interconnected notions: (1) acting on behalf of an institution, (2) conferring of status, (3) being a candidate, and (4) appreciation. The first two of these are so closely related that they must be discussed together. I shall first describe paradigm cases of conferring status outside the artworld and then show how similar actions take place within the artworld. The most clear-cut examples of the conferring of status are certain legal actions of the state. A king's conferring of knighthood, a grand jury's indicting someone, the chairman of the election board certifying that someone is qualified to run for office, or a minister's pronouncing a couple man and wife are examples in which a person or persons acting on behalf of a social institution (the state) confer(s) *legal* status on persons. The congress or a legally constituted commission may confer the status of national park or monument on an area or thing. The examples given suggest that pomp and ceremony are required to establish legal status, but this is not so, although of course a legal system is presupposed. For example, in some jurisdictions common-law marriage is possible—a legal status acquired without ceremony. The conferring of a Ph.D. degree on

someone by a university, the election of someone as president of the Rotary, and the declaring of an object as a relic of the church are examples in which a person or persons confer(s) nonlegal status on persons or things. In such cases some social system or other must exist as the framework within which the conferring takes place, but, as before, ceremony is not required to establish status: for example, a person can acquire the status of wise man or village idiot within a community without ceremony.

Some may feel that the notion of conferring status within the artworld is excessively vague. Certainly this notion is not as clear-cut as the conferring of status within the legal system, where procedures and lines of authority are explicitly defined and incorporated into law. The counterparts in the artworld to specified procedures and lines of authority are nowhere codified, and the artworld carries on its business at the level of customary practice. Still there *is* a practice and this defines a social institution. A social institution need not have a formally established constitution, officers, and bylaws in order to exist and have the capacity to confer status—some social institutions are formal and some are informal. The artworld could become formalized, and perhaps has been to some extent in certain political contexts, but most people who are interested in art would probably consider this a bad thing. Such formality would threaten the freshness and exuberance of art. The core personnel of the artworld is a loosely organized, but nevertheless related, set of persons including artists (understood to refer to painters, writers, composers), producers, museum direc-

tors, museum-goers, theater-goers, reporters for newspapers, critics for publications of all sorts, art historians, art theorists, philosophers of art, and others. These are the people who keep the machinery of the artworld working and thereby provide for its continuing existence. In addition, every person who sees himself as a member of the artworld is thereby a member. Although I have called the persons just listed the core personnel of the artworld, there is a minimum core within that core without which the artworld would not exist. This essential core consists of artists who create the works, "presenters" to present the works, and "goers" who appreciate the works. This minimum core might be called "the presentation group," for it consists of artists whose activity is necessary if anything is to be presented, the presenters (actors, stage managers, and so on), and the goers whose presence and cooperation is necessary in order for anything to be presented. A given person might play more than one of these essential roles in the case of the presentation of a particular work. Critics, historians, and philosophers of art become members of the artworld at some time after the minimum core personnel of a particular art system get that system into operation. All of these roles are institutionalized and must be learned in one way or another by the participants. For example, a theater-goer is not just someone who happens to enter a theater; he is a person who enters with certain expectations and knowledge about what he will experience and an understanding of how he should behave in the face of what he will experience.

Assuming that the existence of the artworld has been established or at least made plausible, the problem is now to see how status is conferred by this institution. My thesis is that, in a way analogous to the way in which a person is certified as qualified for office, or two persons acquire the status of common-law marriage within a legal system, or a person is elected president of the Rotary, or a person acquires the status of wise man within a community, so an artifact can acquire the status of candidate for appreciation within the social system called "the artworld." How can one tell when the status has been conferred? An artifact's hanging in an art museum as part of a show and a performance at a theater are sure signs. There is, of course, no guarantee that one can always know whether something is a candidate for appreciation, just as one cannot always tell whether a given person is a knight or is married. When an object's status depends upon nonexhibited characteristics, a simple look at the object will not necessarily reveal that status. The nonexhibited relation *may* be symbolized by some badge, for example, by a wedding ring, in which case a simple look will reveal the status.

The more important question is that of how the status of candidate for appreciation is conferred. The examples just mentioned, display in a museum and a performance in a theater, seem to suggest that a number of persons are required for the actual conferring of the status. In one sense a number of persons are required but in another sense only one person is required: a number of persons are required to make up the social institution of the art-

world, but only one person is required to act on behalf of the artworld and to confer the status of candidate for appreciation. In fact, many works of art are seen only by one person—the one who creates them—but they are still art. The status in question may be acquired by a single person's acting on behalf of the artworld and *treating an artifact as a candidate for appreciation*. Of course, nothing prevents a group of persons from conferring the status, but it is usually conferred by a single person, the artist who creates the artifact. It may be helpful to compare and contrast the notion of conferring the status of candidate for appreciation with a case in which something is simply presented for appreciation: hopefully this will throw light on the notion of status of candidate. Consider the case of a salesman of plumbing supplies who spreads his wares before us. "Placing before" and "conferring the status of candidate for appreciation" are very different notions, and this difference can be brought out by comparing the salesman's action with the superficially similar act of Duchamp in entering a urinal which he christened *Fountain* in that now-famous art show. The difference is that Duchamp's action took place within the institutional setting of the artworld and the plumbing salesman's action took place outside of it. The salesman could do what Duchamp did, that is, convert a urinal into a work of art, but such a thing probably would not occur to him. Please remember that *Fountain*'s being a work of art does not mean that it is a good one, nor does this qualification insinuate that it is a bad one either. The antics of a particular present-day artist serve to reinforce

the point of the Duchamp case and also to emphasize a significance of the practice of naming works of art. Walter de Maria has in the case of one of his works even gone through the motions, no doubt as a burlesque, of using a procedure used by many legal and some nonlegal institutions—the procedure of licensing. His *High Energy Bar* (a stainless-steel bar) is accompanied by a certificate bearing the name of the work and stating that the bar is a work of art only when the certificate is present. In addition to highlighting the status of art by "certifying" it on a document, this example serves to suggest a significance of the act of naming works of art. An object may acquire the status of art without ever being named but giving it a title makes clear to whomever is interested that an object is a work of art. Specific titles function in a variety of ways—as aids to understanding a work or as a convenient way of identifying it, for example—but any title at all (even *Untitled*) is a badge of status.[11]

The third notion involved in the second condition of the definition is candidacy: a member of the artworld confers the status of candidate for appreciation. The definition does not require that a work of art actually be appreciated, even by one person. The fact is that many, perhaps most, works of art go unappreciated. It is im-

[11] Recently in an article entitled "The Republic of Art" in *British Journal of Aesthetics*, April 1969, pp. 145–56, T. J. Diffey has talked about the status of art being conferred. He, however, is attempting to give an account of something like an evaluative sense of "work of art" rather than the classificatory sense, and consequently the scope of his theory is much narrower than mine.

portant not to build into the definition of the classifica-
tory sense of "work of art" value properties such as
actual appreciation: to do so would make it impossible to
speak of unappreciated works of art. Building in value
properties might even make it awkward to speak of bad
works of art. A theory of art must preserve certain cen-
tral features of the way in which we talk about art, and
we do find it necessary sometimes to speak of unap-
preciated art and of bad art. Also, not every aspect of a
work is included in the candidacy for appreciation; for
example, the color of the back of a painting is not ordi-
narily considered to be something which someone might
think it appropriate to appreciate. The problem of which
aspects of a work of art are to be included within the
candidacy for appreciation is a question I shall pursue
later in Chapter 7 in trying to give an analysis of the
notion of aesthetic object. The definition of "work of
art" should not, therefore, be understood as asserting that
every aspect of a work is included within the candidacy
for appreciation.

The fourth notion involved in the second condition of
the definition is appreciation itself. Some may assume that
the definition is referring to a special kind of *aesthetic*
appreciation. I shall argue later in Chapters 4, 5, and 6
that there is no reason to think that there is a special kind
of aesthetic consciousness, attention, or perception. Simi-
larly, I do not think there is any reason to think that
there is a special kind of aesthetic appreciation. All that
is meant by "appreciation" in the definition is something
like "in experiencing the qualities of a thing one finds

them worthy or valuable," and this meaning applies quite generally both inside and outside the domain of art. Several persons have felt that my account of the institutional theory of art is incomplete because of what they see as my insufficient analysis of appreciation." They have, I believe, thought that there are different kinds of appreciation and that the appreciation in the appreciation of art is somehow typically different from the appreciation in the appreciation of nonart. But the only sense in which there is a difference between the appreciation of art and the appreciation of nonart is that the appreciations have different *objects*. The institutional structure in which the art object is embedded, not different kinds of appreciation, makes the difference between the appreciation of art and the appreciation of nonart.

In a recent article[12] Ted Cohen has raised a question concerning (1) candidacy for appreciation and (2) appreciation as these two were treated in my original attempt to define "art."[13] He claims that in order for it to be possible for candidacy for appreciation to be conferred on something that it must be possible for that thing to be appreciated. Perhaps he is right about this; in any event, I cannot think of any reason to disagree with him on this point. The possibility of appreciation is one constraint on the definition: if something cannot be appreciated, it cannot become art. The question that now arises

[12] "The Possibility of Art: Remarks on a Proposal by Dickie," *Philosophical Review*, January 1973, pp. 69–82.

[13] "Defining Art," *American Philosophical Quarterly*, July 1969, pp. 253–256.

is: is there anything which it is impossible to appreciate? Cohen claims many things cannot be appreciated; for example, "ordinary thumbtacks, cheap white envelopes, the plastic forks given at some drive-in restaurants."[14] But more importantly, he claims that *Fountain* cannot be appreciated. He says that *Fountain* has a point which can be appreciated, but that it is Duchamp's gesture that has significance (can be appreciated) and not *Fountain* itself. I agree that *Fountain* has the significance Cohen attributes to it, namely, that it was a protest against the art of its day. But why cannot the ordinary qualities of *Fountain*—its gleaming white surface, the depth revealed when it reflects images of surrounding objects, its pleasing oval shape—be appreciated. It has qualities similar to those of works by Brancusi and Moore which many do not balk at saying they appreciate. Similarly, thumbtacks, envelopes, and plastic forks have qualities that can be appreciated if one makes the effort to focus attention on them. One of the values of photography is its ability to focus on and bring out the qualities of quite ordinary objects. And the same sort of thing can be done without the benefit of photography by just looking. In short, it seems unlikely to me that any object would not have some quality which is appreciatable and thus likely that the constraint Cohen suggests may well be vacuous. But even if there are some objects that cannot be appreciated, *Fountain* and the other Dadaist creations are not among them.

I should note that in accepting Cohen's claim I am say-

[14] "The Possibility of Art," p. 78.

ing that every work of art must have some minimal *potential* value or worthiness. This fact, however, does not collapse the distinction between the evaluative sense and the classificatory sense of "work of art." The evaluative sense is used when the object it is predicated of is deemed *to be* of substantial, actual value, and that object may be a natural object. I will further note that the appreciatability of a work of art in the classificatory sense is *potential* value which in a given case may never be realized.[15]

The definition I have given contains a reference to the artworld. Consequently, some may have the uncomfortable feeling that my definition is viciously circular. Admittedly, in a sense the definition is circular, but it is not viciously so. If I had said something like "A work of art is an artifact on which a status has been conferred by the artworld" and then said of the artworld only that it confers the status of candidacy for appreciation, then the definition would be viciously circular because the circle would be so small and *uninformative*. I have, however, devoted a considerable amount of space in this chapter to describing and analyzing the historical, organizational, and functional intricacies of the artworld, and if this account is accurate the reader has received a considerable amount of *information* about the artworld. The circle I have run is not small and it is not uninformative. If, in the end, the artworld cannot be described independently of art, that is, if the description contains references to art

[15] I realized that I must make the two points noted in this paragraph as the result of a conversation with Mark Venezia. I wish to thank him for the stimulation of his remarks.

historians, art reporters, plays, theaters, and so on, then the definition strictly speaking is circular. It is not, however, viciously so, because the whole account in which the definition is embedded contains a great deal of information about the artworld. One must not focus narrowly on the definition alone: for what is important to see is that art is an institutional concept and this requires seeing the definition in the context of the whole account. I suspect that the "problem" of circularity will arise frequently, perhaps always, when institutional concepts are dealt with.

III

The instances of Dadaist art and similar present-day developments which have served to bring the institutional nature of art to our attention suggest several questions. First, if Duchamp can convert such artifacts as a urinal, a snow shovel, and a hatrack into works of art, why can't natural objects such as driftwood also become works of art in the classificatory sense? Perhaps they can if any one of a number of things is done to them. One way in which this might happen would be for someone to pick up a natural object, take it home, and hang it on the wall. Another way would be to pick up a natural object and enter it in an exhibition. I was assuming earlier, by the way, that the piece of driftwood referred to in Weitz's sentence was in place on a beach and untouched by human hand or at least untouched by any human intention and therefore was art in the evaluative or derivative sense. Natural objects which become works of art in the clas-

sificatory sense are artifactualized without the use of tools —artifactuality is conferred on the object rather than worked on it. This means that natural objects which become works of art acquire their artifactuality at the same time that the status of candidate for appreciation is conferred on them, although the act that confers artifactuality is not the same act that confers the status of candidate for appreciation. But perhaps a similar thing ordinarily happens with paintings and poems; they come to exist as artifacts at the same time that they have the status of candidate for appreciation conferred on them. Of course, being an artifact and being a candidate for appreciation are not the same thing—they are two properties which may be acquired at the same time. Many may find the notion of artifactuality being conferred rather than "worked" on an object too strange to accept and admittedly it is an unusual conception. It may be that a special account will have to be worked out for exhibited driftwood and similar cases.

Another question arising with some frequency in connection with discussions of the concept of art and seeming especially relevant in the context of the institutional theory is "How are we to conceive of paintings done by individuals such as Betsy the chimpanzee from the Baltimore Zoo?" Calling Betsy's products paintings is not meant to prejudge that they are works of art, it is just that some word is needed to refer to them. The question of whether Betsy's paintings are art depends upon what is done with them. For example, a year or two ago the Field Museum of Natural History in Chicago exhibited

some chimpanzee and gorilla paintings. We must say that these paintings are not works of art. If, however, they had been exhibited a few miles away at the Chicago Art Institute they would have been works of art—the paintings would have been art if the director of the Art Institute had been willing to go out on a limb for his fellow primates. A great deal depends upon the institutional setting: one institutional setting is congenial to conferring the status of art and the other is not. Please note that although paintings such as Betsy's would remain her paintings even if exhibited at an art museum, they would be the *art* of the person responsible for their being exhibited. Betsy would not (I assume) be able to conceive of herself in such a way as to be a member of the artworld and, hence, would not be able to confer the relevant status. Art is a concept which necessarily involves human intentionality. These last remarks are not intended to denigrate the value (including beauty) of the paintings of chimpanzees shown at natural history museums or the creations of bower birds, but as remarks about what falls under a particular concept.

Danto in "Art Works and Real Things" discusses defeating conditions of the ascriptivity of art.[16] He considers fake paintings, that is, copies of original paintings which are attributed to the creators of the original paintings. He argues that a painting's being a fake prevents it from being a work of art, maintaining that originality is an analytical requirement of being a work of art. That a

[16] Pages 12–14.

work is derivative or imitative does not, however, he thinks, prevent it from being a work of art. I think Danto is right about fake paintings, and I can express this in terms of my own account by saying that originality in paintings is an antecedent requirement for the conferring of the candidacy for appreciation. Similar sorts of things would have to be said for similar cases in the arts other than painting. One consequence of this requirement is that there are many works of nonart which people take to be works of art, namely, those fake paintings which are not known to be fakes. When fakes are discovered to be fakes, they do not lose that status of art because they never had the status in the first place, despite what almost everyone had thought. There is some analogy here with patent law. Once an invention has been patented, one exactly like it cannot be patented—the patent for just that invention has been "used up." In the case of patenting, of course, whether the second device is a copy or independently derived is unimportant, but the copying aspect is crucial in the artistic case. The Van Meegeren painting that was not a copy of an actual Vermeer but a painting done in the manner of Vermeer with a forged signature is a somewhat more complicated case. The painting with the forged signature is not a work of art, but if Van Meegeren had signed his own name the painting would have been.

Strictly speaking, since originality is an analytic requirement for a painting to be a work of art, an originality clause should be incorporated into my definition of "work of art." But since I have not given any analysis of

the originality requirement with respect to works other than paintings, I am not in a position to supplement the definition in this way. All I can say at this time is what I said just above, namely, that originality in paintings is an antecedent requirement for the conferring of the candidacy for appreciation and that considerations of a similar sort probably apply in the other arts.

Weitz charges that the defining of "art" or its subconcepts forecloses on creativity. Some of the traditional definitions of "art" *may* have and some of the traditional definitions of its subconcepts probably *did* foreclose on creativity, but this danger is now past. At one time a playwright, for example, may have conceived of and wished to write a play with tragic features but lacking a defining characteristic as specified by, say, Aristotle's definition of "tragedy." Faced with this dilemma the playwright might have been intimidated into abandoning his project. With the present-day disregard for established genres, however, and the clamor for novelty in art, this obstacle to creativity no longer exists. Today, if a new and unusual work is created and it is similar to some members of an established type of art, it will usually be accommodated within that type, or if the new work is very unlike any existing works then a new subconcept will probably be created. Artists today are not easily intimidated, and they regard art genres as loose guidelines rather than rigid specifications. Even if a philosopher's remarks were to have an effect on what artists do today, the institutional conception of art would certainly not foreclose on creativity. The requirement of artifactuality

cannot prevent creativity, since artifactuality is a necessary condition of creativity. There cannot be an instance of creativity without an artifact of some kind being produced. The second requirement involving the conferring of status could not inhibit creativity; in fact, it encourages it. Since under the definition anything whatever may become art, the definition imposes no restraints on creativity.

The institutional theory of art may sound like saying, "A work of art is an object of which someone has said, 'I christen this object a work of art.'" And it is rather like that, although this does not mean that the conferring of the status of art is a simple matter. Just as the christening of a child has as its background the history and structure of the church, conferring the status of art has as its background the Byzantine complexity of the artworld. Some may find it strange that in the nonart cases discussed, there are ways in which the conferring can go wrong, while that does not appear to be true in art. For example, an indictment might be improperly drawn up and the person charged would not actually be indicted, but nothing parallel seems possible in the case of art. This fact just reflects the differences between the artworld and legal institutions: the legal system deals with matters of grave personal consequences and its procedures must reflect this; the artworld deals with important matters also but they are of a different sort entirely. The artworld does not require rigid procedures; it admits and even encourages frivolity and caprice without losing its serious purpose. Please note that not all legal procedures are as

rigid as court procedures and that mistakes made in conferring certain kinds of legal status are not fatal to that status. A minister may make mistakes in reading the marriage ceremony, but the couple that stands before him will still acquire the status of being married. If, however, a mistake cannot be made *in* conferring the status of art, a mistake can be made *by* conferring it. In conferring the status of art on an object one assumes a certain kind of responsibility for the object in its new status—presenting a candidate for appreciation always allows the possibility that no one will appreciate it and that the person who did the conferring will thereby lose face. One *can* make a work of art out of a sow's ear, but that does not necessarily make it a silk purse.

IV

Once the institutional nature of art is noted, the roles that such "theories of art" as the imitation and expression theories played in thinking about art can be seen in an interesting perspective. For example, as long as all art was imitative or thought to be imitative, imitation was thought to be a universal property of art. Not surprisingly, what was thought to be the only universal property of art was taken to be the defining property of art. What happened was that an assumed always-accompanying property was mistaken for an essential property, and this mistake led to a mistaken theory of art. Once the imitation theory was formulated, it tended to work in a normative way to encourage artists to be imitative. Of course, philosophical theories do not generally have much effect on the prac-

tices of men. The imitation theory in the past may, however, have had more than the usual slight impact, because it was based on a widespread feature of art and therefore reinforced an emphasis on an easily perceived characteristic and because the class of artists was relatively small and contained lines of communication.

The role played by the expression theory was quite different from that of the imitation theory. It was seen as a replacement for the imitation theory and served as its correction. Developments in art had shown that the imitation theory was incorrect and it was quite natural to seek a substitute that focused on another exhibited property of art, in this case its expressive qualities, interpreting them as expressions of the artists. I suspect that the expression theory had a normative role in a way that the imitation theory did not. That is, the expression theory was on the part of many of its proponents an attempt to "reform" art. Whether the expression theorists saw themselves as attempting to influence the creation of art with a certain kind of content or to separate art from something which pretended to be art, they aimed at reform.

From the point of view of the institutional theory, both the imitation theory and the expression theory are mistaken as theories of art. If, however, they are approached as attempts to focus attention on aspects of art (its representative and expressive qualities) which have been and continue to be of great importance, then they have served and continue to serve a valuable function. The institutional definition of "art" does not reveal everything that art can do. A great deal remains to be

said about the kinds of thing that art can do, and the imitation and expression theories indicate what *some* of these things are, although not in a perfectly straightforward way.

I have now said all that I am going to say about the concept of art, until I return to the topic at the end of Chapter 7, where I shall discuss it briefly in an attempt to ascertain the relation between works of art and aesthetic objects. In the next chapter, I begin the discussion of "the aesthetic," which in one way or another will be the topic of the remainder of the book, and trace the eighteenth- and nineteenth-century background of the concept.

2

Taste and Attitude: The Origin of the Aesthetic

In 1961, Jerome Stolnitz published three articles that greatly increased our understanding of the development of aesthetics in the eighteenth century.[1] These articles focused attention on the rise and influence of the notion of disinterestedness, on the development of eighteenth-century British philosophies of taste, on the decline of beauty as the organizing concept of our thinking about the appreciation of art and nature, and on the emergence of theories of aesthetic attitude. For all their importance these articles contain some misinterpretations. Stolnitz incorrectly asserts that Joseph Addison, who wrote at the beginning of the eighteenth century, was the earliest exponent of the aesthetic-attitude theory. He also asserts that Archibald Alison, who wrote at the end of the

[1] "On the Origins of 'Aesthetic Disinterestedness,'" *Journal of Aesthetics and Art Criticism*, Winter 1961, pp. 131–143; "'Beauty': Some Stages in the History of an Idea," *Journal of the History of Ideas*, April–June 1961, pp. 185–204; "On the Significance of Lord Shaftesbury in Modern Aesthetic Theory," *Philosophical Quarterly*, April 1961, pp. 97–113.

eighteenth century, was an aesthetic-attitude theorist, but he fails to note essential aspects of Alison's theory which prevent him from being so classified. The positive thesis of this chapter is that the British philosophers of the eighteenth century were only the forerunners of the aesthetic-attitude theory and that the first attitude theorists were German thinkers of the late eighteenth and early nineteenth centuries. Even if my historical theses go awry, I hope that my analyses of the structure of the theory of taste and of the structure of aesthetic-attitude theory will make possible more precise discussion of these theories and their origins.

In Section I, I shall describe the general structure of the theory of taste, a structure which held constant from the beginning of the eighteenth century to its end, and then give a brief account of the structure of the aesthetic-attitude theory. In Section II, I shall show how the theories of Hutcheson, Burke, and Hume[2] exemplify the structure of the theory of taste. For reasons of space, I shall discuss only these philosophers' treatments of beauty and ignore what they say about the sublime. In Section III, I shall try to show why Stolnitz is wrong in thinking that Addison and Alison are aesthetic-attitude theorists. Finally, in Section IV, I shall try to show that Kant's theory of taste departs in a significant way from the earlier theories of taste and that Schiller and Schopenhauer are either aesthetic-attitude theorists or very close

[2] I am here concerned only with Hume's view of taste as it is expressed in his "Of the Standard of Taste," *Essays and Treatises*, vol. 1 (London, 1784).

to it. I should note that my primary positive concern is with the analysis and classification of historical theories and not with historical priorities. Schiller may not be the first aesthetic-attitude or proto-aesthetic-attitude theorist, but he clearly was an early one and an influential one. My main concern is to point out the important differences between theories of taste and aesthetic-attitude theories.

I

An analysis of the theory of taste reveals that taste is conceived of as having a five-part structure: two mental faculties, a perceivable object of a specific sort, a mental product which results from the reaction to the perception of a specific kind of object, and finally judgments of taste. The first element of the structure is perception, the faculty by which contact with the external world is established. Although many epistemological problems are involved with perception, a discussion of them is not necessary in order to display the structure of the theory of taste; later I will show that certain aesthetic-attitude theories make perception or related notions central. For the theory of taste, however, perception is simply the way we come to know features of the world. Taste, according to each theory, is interested in only a specific kind of object in the external world; for example, in the case of Hutcheson the specific feature is "uniformity in variety." The specific kind of object is the second structural element of the theory. The third and central element is the faculty of taste. This faculty, unlike percep-

tion, is not cognitive, but reactive. That is, the faculty of taste is the aspect of mind which, according to the theory, reacts to the perception of a specific kind of object. The fourth element in the theory is the mental product of the faculty of taste which is variously called pleasure, approval, and the like. The fifth element of the theory is judgments of taste which may take a particular form ("This flower is beautiful") or a general form ("Things with such and such a property are always beautiful"). Judgments of taste are more complex than their grammatical form seems to indicate. The subjects of such judgments—"this flower" and "things with such and such a property"—refer to objects in the external world; "beautiful," however, does not refer to a property of the external stimulus, but rather to the pleasure aroused by the stimulus. Thus for the eighteenth-century theories of taste, judgments of taste are ways of saying that a perceived thing arouses pleasure or perceived sorts of things arouse pleasure. Significant concern with judgments of taste is found only in Hume and in Kant. The other theories, however, can be interpreted in the light of these two more developed theories.

Listing the elements of the theory is not enough, however. The background assumptions of the theory of taste must also be made clear. Not every pleasure that is aroused is a pleasure of taste, even when it is aroused by a work of art. First, the pleasure must be disinterested. Second, the subject in which the pleasure is aroused must be in a certain frame of mind, calm, attentive, and not under the influence of certain distorting associations of

ideas. The theorists of taste, except for Kant, conceived of their task as an exercise in psychological inquiry through which by observation and introspection they could discover, when certain standard conditions were met, the regular reactions of human nature to certain phenomena.

The structure of aesthetic-attitude theory is simpler than that of the theory of taste in that it refers to only two basic elements: perception (or consciousness) and aesthetic judgments. (The earlier aesthetic theories speak of aesthetic consciousness or aesthetic contemplation rather than aesthetic perception, but the role of the variously named mental functions is similar.) In the aesthetic theories the function of perception is made more complicated than in the earlier theories of taste, and this makes a specific kind of object, a faculty of taste, and a product pleasure unnecessary for them. The theory divides perception into ordinary perception and aesthetic perception. Aesthetic judgments refer to whatever is the object of aesthetic perception; such referents today are called "aesthetic objects" by attitude theorists. This theory can be summed up as the view that any object can become an aesthetic object if only aesthetic perception is turned on it.

The theory of taste and the attitude theory give opposite accounts of the relation of the subject to its object. For the theories of taste a specific kind of object *triggers* a reaction in the subject, but for the aesthetic-attitude theories either a certain mode of perception or consciousness is a *necessary condition* for the apprehension and

appreciation of the aesthetic character which an object possesses independently of that mode of perception or consciousness or a certain mode of perception or consciousness *imposes* an aesthetic character on (any) object. Aesthetic-attitude theories, then, come in weaker versions in which the "attitude" is simply a necessary condition for access to aesthetic features of objects and in stronger versions in which the "attitude" in some way determines an object to have aesthetic features. Both the taste and attitude theories are developments within the same philosophical tradition—a tradition which places great stress on the subject. Both theories are highly subjectivized when compared with the objective theories of beauty of Platonism and Neoplatonism. But whereas the theory of taste retains some shred of contact with the external world by requiring that a specific kind of object triggers a subject, attitude theories dispense with this requirement and are completely subjectivized. When I say that taste and attitude theories are subjective, I mean that the theories claim that the existence of the beautiful is in some way dependent upon the existence of a subject and his experience. When I say that the attitude theories are more subjective than the taste theories, I mean that whereas the taste theories claim that the beautiful depends in part on a specific kind of object in the external world which is independent of the subject, aesthetic-attitude theories claim either that specific kinds of objects are unnecessary because the beautiful is totally dependent upon the mental state of a subject or that the various kinds of beautiful objects are accessible only to subjects

in certain kinds of mental states. In both taste and attitude theories disinterestedness plays a central but quite different sort of role. In the earlier theories it is the faculty of taste, the function of which is to react to the perception of specific qualities, that is disinterested; in the later theories it is perception or consciousness itself, the basic function of which is to provide awareness of the characteristics of the external world, that is (on occasion) disinterested. In the aesthetic-attitude theories disinterestedness has moved to a more fundamental position from which it can on some occasions either determine the nature of perceived (aesthetic) reality or be the only avenue to a certain kind of (aesthetic) reality.

II

It might at first seem reasonable to begin a discussion of actual theories of taste with a discussion of Shaftesbury's views, but I shall not do so. As Stolnitz says, Shaftesbury was the first to relate disinterestedness to the appreciation of beauty and thereby began an influential tradition. Because of his Neoplatonism, however, Shaftesbury does not fit in with the British philosophers he influenced. The empiricism of Hutcheson, Burke, Hume, and the other British theorists turned them away from Shaftesbury's concern with the Platonic Form of Beauty toward sensory experience, and their psychological method focused their attention on the reactions of men. Consequently, as I shall be using the expression "theory of taste," Shaftesbury's views do not fall into the category. The point of discussing some actual theories of

taste in this section is to illustrate how theories which differ rather markedly nevertheless exemplify the five-part structure described in the last section.

Francis Hutcheson was the first of the systematic taste theorists, and his theory served as a prototype for subsequent British thinkers. All of the British theorists agreed on a Lockean view of perception, so it is unnecessary to discuss it in the case of each man. For Hutcheson, as was already indicated, the specific kind of object which triggers the faculty of taste is uniformity in variety. That this particular kind of object affects the human constitution in the way it does is just a fact and could have been otherwise, or, as Hutcheson puts it, the Deity could have created men differently. Hutcheson conceives of his theory as an empirical description of human nature. He calls the faculty of taste a sense, or more specifically an internal sense which contrasts with the external senses such as vision and hearing. But the word "sense" is not used to indicate that the sense of beauty has a cognitive function; it is used to indicate that the *reaction* to uniformity in variety is immediate and not dependent upon calculation of any kind. The sense of beauty functions in a way analogous to the way in which the sense of sight functions when one sees a color, that is, immediately and involuntarily. In his later writings Hutcheson uses the technical term "reflex sense" to refer to the sense of beauty. This expression, which catches his meaning exactly, was later adopted by Alexander Gerard for his theory of taste.[3] The mental product of the sense of

[3] *An Essay on Taste* (1759), facsimile reproduction of the 3d

beauty is pleasure, and it is this pleasure that the term "beauty" refers to in Hutcheson's view: "The Word Beauty is taken for the Idea rais'd in us."[4] From the general account of judgments of taste already given it is easy enough to see what Hutcheson's view of them would be.

Edmund Burke's theory does not provide a formula like "uniformity in variety"; he simply furnishes a list of the qualities of objects to which subjects supposedly respond. These qualities are smallness, smoothness, being polished, deviating insensibly from the right line, lightness, and delicacy. Whether this is supposed to be a complete list or not is not clear, but qualities appear on the list because they produce disinterested pleasure, which is the fourth element of the structure. The faculty of taste for Burke has no special name such as "sense" or "imagination." Burke begins his book with a general discussion of motives—curiosity, pleasure, and pain; he bases his view of the sublime on pain and his view of beauty on pleasure. In Burke's view the faculty of taste must be described simply as the disposition to respond with disinterested pleasure to the listed qualities. Burke's conception of judgments of taste derives from his definition of "beauty": "By beauty I mean, that quality or those qualities in bodies by which they cause love."[5] Thus "This

ed. (1780), intro. by Walter J. Hipple (Gainsville, Florida, 1963), pp. 1–2.

[4] *An Inquiry into the Original of Our Ideas of Beauty and Virtue*, 2d ed. (London, 1726), p. 7.

[5] *A Philosophical Enquiry into the Origin of Our Ideas of the Sublime and Beautiful*, intro. by J. T. Boulton (London, 1958), p. 91.

flower is beautiful" ultimately means that the flower has qualities which produce love (disinterested pleasure).

David Hume sums up almost the whole of his theory of taste in one short passage from his essay "Of the Standard of Taste": "Though it be certain, that beauty and deformity, more than sweet and bitter, are not qualities in objects, but belong entirely to the sentiment, internal or external; it must be allowed, that there are certain qualities in objects, which are fitted by nature to produce those particular feelings."[6] Hume, no doubt seeing the difficulties involved in specifying a formula or a list of qualities, speaks only of "certain qualities in objects." He does not speak more precisely of these qualities anywhere in the essay. The faculty of taste is sentiment and the mental product of the faculty is "particular feelings," elsewhere called pleasures in the case of beauty and displeasure in the case of deformity. Hume is the first of the British philosophers of taste to speak at all extensively of judgments of taste, which he calls "the rules of composition" or "the general rules of beauty," or perhaps it ought to be said that these "rules" are supposed to be derived from general judgments of taste. These general judgments are conceived of by Hume as empirical generalizations of "what has been universally found to please in all countries and in all ages."[7] Hume describes in careful detail how the experiments to discover what pleases and displeases are to be set up, thus explicitly displaying the British philosophers' conception of the empirical na-

[6] Page 250.
[7] *Ibid.*, p. 246.

ture of their inquiries. At the end of his essay Hume introduces an element of relativity into his theory by speaking of disagreements in taste due to age and temperament which are "entirely blameless on both sides."[8] The other theories make no such provisions.

<div align="center">III</div>

Stolnitz closes "On the Origins of 'Aesthetic Disinterestedness' " with a long discussion of Joseph Addison's "The Pleasures of the Imagination" in which he in effect gives Addison credit for being the first of the British, empiricist-minded philosophers of taste and also for being the first "in taking 'aesthetic perception' to be foundational to aesthetic theory."[9] Stolnitz is no doubt correct in the first claim, for while Shaftesbury's discussion of disinterestedness is slightly earlier than Addison's essays, Shaftesbury's Neoplatonism makes his theory very different from that of Hutcheson, Hume, and other British philosophers. Stolnitz's claim that the notion of aesthetic perception is a part of the theories of the eighteenth-century British philosophers is, however, anachronistic.

Stolnitz seems to rest his claim concerning aesthetic perception on two passages from Addison. He quotes these two together as follows: "A man of polite imagination [has] a kind of property in everything he sees: . . . he looks upon the world, as it were in another light, and discovers in it a multiple of charms, that conceal themselves from the generality of mankind" (no. 411, p. 325).

[8] *Ibid.*, pp. 260–261.
[9] Page 143.

Hence "almost every thing about us" can arouse a plea-
sure of the imagination (no. 413, p. 334)."[10] Admittedly
these two quotes sound rather like the remarks of Scho-
penhauer or some more recent aesthetic-attitude theorist.
Looking at the world "in another light" sounds as if
Addison is talking about a special mode of perception.
And "almost every thing about us" possibly arousing a
pleasure of the imagination sounds similar to the view
that almost anything can become the object of aesthetic
perception and hence an aesthetic object.

The second quotation, however, occurs in a passage in
which Addison is talking about the goodness of God who
has filled the world with so many beautiful things, that
is, things which arouse the pleasures of the imagination.
But this theological claim surely ought not to be con-
fused with the claim that almost any object can become
the object of aesthetic perception. Also, note that the
objects "about us" arouse pleasures, that is, trigger plea-
sure in a subject, which is characteristic of theories of
taste rather than theories of aesthetic perception. The
other quotation, the "looking on the world in a new
light" passage, is an isolated and undeveloped remark by
a philosophically unsophisticated writer. Neither Addi-
son, nor any of the other British philosophers of the
eighteenth century, could have understood this remark
to be about aesthetic perception. The view that the cog-
nitive faculty of perception imposes a character of any
kind on the objects of perception came to prominence in
the epistemology of Kant. The theory of a disinterested

[10] *Ibid.*, p. 142.

perception which could either impose a character on reality or be a necessary condition for the perception of aesthetic features was not a live option until the idealistic aspects of Kant's epistemology influenced thought about the appreciation of art and nature. The view of perception with which the eighteenth-century British philosophers of taste worked was that of Locke in which the percipient is considered to be more or less passive. Stolnitz is right in saying that Addison's essays "constitute a starting-point of modern aesthetics," but wrong in thinking that he makes aesthetic perception foundational.

In fact, Addison's theory fits neatly into the same structure exemplified by Hutcheson, Burke, and Hume. The first element of Addison's theory is perception, just as with the other British thinkers. The following passage reveals Addison's version of the second element:

There is not perhaps any real beauty or deformity more in one piece of matter than another, because we might have been so made, that whatsoever now appears loathsome to us. might have shown itself agreeable; but we find by experience, that there are several modifications of matter, which the mind, without any previous consideration, pronounces at first sight beautiful or deformed.[11]

Addison, like Hume, gives neither formula nor list, but merely asserts that "several modifications of matter" trigger the pleasures of the imagination. This passage also reveals Addison's rejection of any Platonic conception of beauty ("real beauty or deformity") in favor of a view which conceives of beauty as essentially related to human

[11] *The Works of Joseph Addison,* vol. 3 (London, 1856), p. 399.

nature. The faculty of taste for Addison is of course the imagination, although as Stolnitz points out he is very vague as to what he means by the term "imagination." The main function of his notion of the imagination, again as Stolnitz points out, is that it furnishes a locus for working disinterestedness into his theory. The mental product of the faculty of taste is disinterested pleasure. The analysis of judgments of taste which Addison's theory entails is of the same sort as for the other theorists of taste.

Archibald Alison, who wrote at the end of the eighteenth century, is declared by Stolnitz to be a clear case of an aesthetic-attitude theorist with a fully developed conception of disinterested perception or attention. While Alison's views may seem to come closer to those of the aesthetic-attitude theorists than do the views of the other British thinkers discussed here, he does not claim that there are two kinds of perception or attention and his theory exhibits all the usual five elements of a theory of taste.

First, Stolnitz is wrong in claiming that Alison broke with the tradition of trying to isolate the specific kind of object which triggers the faculty of taste. Stolnitz quotes Alison as saying that such formulas are "altogether impossible."[12] The passage near the end of Volume I from which this phrase comes, however, reads, "To reduce the great variety of instances of Beauty in Forms to any simple principle, seems at first sight altogether impos-

[12] " 'Beauty,' " p. 200.

sible."[13] Alison had already argued earlier in Volume I
that it is expressions of mind or signs of qualities of mind
which trigger the faculty of taste. Alison had there raised
the question: "What is the source of the Sublimity and
Beauty of the Material World?"[14] Alison rejects the
Hutchesonian and other formulas which find the source
in aspects of matter (uniformity in variety, smallness,
etc.) but he still seeks the source, and thinks he finds it
in the expressions of minds. He concludes Volume II:
"the Beauty and Sublimity which is felt in the various
appearances of matter, are finally to be ascribed to their
Expression of Mind; or to their being, either directly or
indirectly, the signs of those qualities of Mind which are
fitted by the constitution of our Nature, to affect us with
pleasing or interesting Emotions."[15] In the case of art it is
the expressions of the qualities of mind of the artist
which trigger the faculty of taste; in the case of nature
it is the expressions of the qualities of mind of "the Di-
vine Artist." Alison's formula is more complicated than
the earlier formulas, and more grandiose—it involves a
commitment to the existence of God—but it is neverthe-
less a formula.

Alison's description of the faculty of taste and its men-
tal product is as specific and complicated as the descrip-
tions of the earlier thinkers are vague and simple. The

[13] *Essays on the Nature and Principles of Taste*, 5th ed.
(Edinburgh, 1817), vol. 1, p. 316.
[14] *Ibid.*, pp. 175–176.
[15] *Ibid.*, vol. 2, p. 423.

basic faculty of taste for Alison is, I suppose, the imagination plus the power to produce pleasure and emotion. The mental product of this complex faculty or set of faculties consists of trains of unified thoughts in the imagination produced by association, simple pleasures, complex pleasures, simple emotions, and something Alison calls the emotion of taste. It is in connection with Alison's account of conditions which are conducive to and destructive of the proper functioning of the faculty of taste that Stolnitz makes the mistake of thinking Alison is talking about disinterested perception or attention. As Stolnitz notes, Alison describes the state of mind most favorable to the proper operation of the faculty of taste as that "in which the attention is so little occupied by any private or particular object of thought, as to leave us open to all the impressions which the objects that are before us can produce."[16] Alison also gives examples of the kinds of things which can interfere with the proper state of mind: being in pain or grieving; being a husbandman, a businessman, or a philosopher, all of whom as such are presumed to be oblivious to the beauties of their surroundings. Stolnitz concludes from these cases that "the question has become, for Alison, not merely one of motive but of attention,"[17] meaning by this that Alison has distinguished disinterested attention from ordinary attention. But Alison has only talked about attention to, say, signs of qualities of a mind or attention to, say, one's pain. He is not claiming that there are two kinds of attention

[16] *Ibid.*, vol. 1, p. 10.
[17] "On the Origins of 'Aesthetic Disinterestedness,' " p. 137.

or perception but only that there is attention to aspects of the external world and *in*attention to such aspects. What Alison says about perception indicates that he understands the notion in the usual Lockean way. He does not give any indication that he thinks that the external senses can function in two ways. I will not explain the analysis of judgments of taste that Alison's theory entails because it follows the general pattern of the theory of taste.

IV

Kant's account of judgments of taste, set forth in *The Critique of Judgement*,[18] exhibits the same general structure as the theories of the British philosophers and clearly he was influenced by them. He, of course, differs from them in claiming that judgments of taste must always be singular judgments, never generalizations, and in claiming that judgments of taste have a priori foundations and therefore cannot be validated by psychological inquiry. After showing how Kant's view fits the general structure of the theory of taste, I will try to show how his theory involves an important philosophical departure which was to have far-reaching influence.

In the first moment of the "Analytic of the Beautiful" Kant asserts that judgments of taste are subjective in one of the many senses in which he uses the term and concern disinterested pleasure (the mental product). Kant's version of the faculty of taste is developed in the second and

[18] J. C. Meredith, trans. (Oxford, 1928).

fourth moments of the "Analytic of the Beautiful" in which he tries to explain the universality and necessity of judgments of taste. When a person is aware of a certain kind of object which is devoid of interest and which is represented apart from concepts, the cognitive faculties (common to all men) can engage in "free play." This harmony of the cognitive faculties produces the disinterested pleasure characteristic of beauty. Thus for Kant, the apparatus of taste is the cognitive faculties functioning in a particular way.

In the third moment of the "Analytic" Kant describes the specific kind of object which triggers the faculty of taste. For reasons which involve the overall argument of the third *Critique*, Kant wishes to involve the notion of purpose in his account of judgments of taste and it is here in the third moment that purpose is worked in. Actual purpose, however, is ruled out for Kant because that would involve representation under a concept. Kant's solution to this dilemma is to declare that it is the *form* of purpose, not the recognition of an actual purpose which triggers the faculty of taste. Note that not every form triggers the faculty of taste, so that the qualification "of purpose" serves to mark out a special class of forms. According to Kant's epistemological theory, form derives from Sensibility, the faculty of mind which *gives* experience its spatial and temporal relations. The form aspect of the form of purpose, therefore, derives from a faculty of the subject's mind and is subjective in that its existence depends upon a subject. Of course, for Kant form is ob-

jective in the sense that all subjects experience the same kind of spatial and temporal relations.

For Kant, like the British thinkers, the faculty of taste is subjective in the sense that it is an aspect of a subject. Also for Kant and the British philosophers, the product pleasure is subjective in that its existence depends upon the existence of a subject. But unlike the British thinkers, for Kant the object which triggers the faculty of taste is also subjective. The nature of this object—the form of purpose—is in part dependent upon and determined by the experiencing subject. In Kant's theory, as just noted, the spatio-temporal relations which constitute the form aspect of a form of purpose derive from Sensibility. Thus for Kant even the object of the faculty of taste is not independent of the subject. Such a radical subjectivity was not possible for the British philosophers because the Lockean account of perception they were presupposing does not give the perceiving subject such an active role in determining the characteristics of its object. The most striking novelty of Kant's epistemology thus plays an important role in his theory of taste.

Kant's theory retains all the characteristic features of the earlier theories, but he severs the last remaining connection with the objective world as conceived by the British philosophers by making the object of taste (the form of purpose) subjective. Now that the subject has achieved such a dominant role, the way is clear for the development of aesthetic theories—strong versions of the aesthetic-attitude theory which place the subject in com-

plete control and which place no limitations (or almost none) on the objects which can be seen as beautiful, and weak versions of the aesthetic-attitude theory which make a state of the subject's mind a necessary condition for the experience of beautiful objects.

The views of Friedrich Schiller as they were worked out in his *Letters on the Aesthetic Education of Man*[19] are a halfway house between Kant's theory of taste and aesthetic theory. A close connection obtains between Schiller's theory and Kant's theory. Schiller read *The Critique of Judgement* soon after it was first published, and he used Kant's doctrine and terminology plus that of Fichte as the basis for his own theory. It is very difficult, perhaps impossible, to get a clear picture of the Kantian-like view that he developed. His presentation is unsystematic and repetitious, and he continually changes the names he gives to the opposed forces which are central to his theory—now calling them "person" and "condition," later "form-drive" and "sense-drive," and still later other names. However, the general outlines of what may be called a theory do exist. Incidentally, the large-scale goal of the *Letters* is to show how the aesthetic education of man can contribute to the proper political organization of society, but this will be ignored here.

Schiller has two complaints against Kant's theory—he thinks it too subjective and finds its formalism, which makes the arabesque the paradigm of beauty, too restric-

[19] E. M. Wilkinson and L. A. Willoughby, eds. and trans. (Oxford, 1967).

tive. His own theory, nevertheless, turns out to be as subjective as Kant's or more so. On the other hand, he does manage to get away from Kant's formalism.

Perhaps the most striking thing about the *Letters* is that Schiller uses the term "aesthetic" very close to the way in which it is used today by aesthetic-attitude theorists. Kant had used the term to cover all experiences of pleasure, but Schiller used it in the more restricted sense of applying only to disinterested appreciation.[20] Schiller's account of disinterested appreciation involves an adaptation of the Kantian notion of the free play of the cognitive faculties. Schiller speaks of opposing forces, life and form, in human nature. The first is the source of the sensuous and the latter of principle. If either force dominates the other, the result is bad; either unregulated sensuousness or joyless prudishness results. What is desirable is that the two forces be in equilibrium; this produces what Schiller calls "the cultivated man." He calls the equilibrium "the aesthetic state." Schiller writes that "beauty results from the reciprocal action of the two opposed drives."[21] This seems to say that a state of consciousness is primary and beauty is a function of that state. Thus Schiller's conception of beauty is even more subjective than Kant's.

Schiller also gives an account of the *object* of aesthetic appreciation and here the background is the Kantian conception of appearance or as Schiller calls it in the *Letters* "semblance." "The reality of things is the work of things

[20] *Ibid.*, p. 205.
[21] *Ibid.*, p. 111.

themselves; the semblance of things is the work of man; and a nature which delights in semblance is no longer taking pleasure in what it receives, but in what it does."[22] He is here asserting the Kantian view that appearance or semblance is a product of the structuring mind, and observing that delight in semblance is delight in an object which the person who is delighted has produced. In the paragraph following the passage just quoted, Schiller distinguishes aesthetic semblance from other semblances by characterizing it as semblance "which we love just because it is semblance." Aesthetic semblance is distinguished from all other appearance by the attitude that is taken toward it—a disinterested attitude, we love it for itself and no other reason.

Probably a clear, detailed account of the relation or relations between the aesthetic state of equilibrium and its object, aesthetic semblance, is not possible. Clearly, however, Schiller has taken us further along the road which leads to aesthetic theory. The notion of the aesthetic is consciously and explicitly at the center of Schiller's theorizing. And of equal importance, the object of aesthetic contemplation, semblance, is not restricted to being a specific kind of thing as is the case with Kant's and the other theories of taste.

Although in the last analysis perhaps Schopenhauer's aesthetic doctrines are not as easy to understand as they first appear to be, they are accessible—much more so than Schiller's. Schopenhauer's aesthetic theory is clearly laid out as part of a comprehensive metaphysical system, and

[22] *Ibid.*, p. 193.

once one is inside the system it is relatively easy to find one's way around.

The main goal of Schopenhauer's metaphysics is to show the way to escape the strivings of the will. Aesthetic contemplation in his theory is viewed as a temporary release from the domination of the will. His basic ontological entities are will and Platonic ideas. Will is manifested in individual *subjects* (persons) and in other aspects of nature and the Platonic ideas are the *objects* of knowledge. Schopenhauer speaks of two kinds of knowledge: an inferior kind which has as its objects the spatial, temporal, and causal relations that obtain among individual things and which is tied to the will, and a superior kind of knowledge which has Platonic ideas as its objects. The Kantian as well as the Platonic elements of this scheme are obvious. As it turns out, aesthetic contemplation is identical with the superior kind of knowledge.

Schopenhauer first characterizes aesthetic contemplation in terms of perception: It is a relinquishing of "the common way of looking at things"; in it a man "gives the whole power of his mind to perception" and "he can no longer separate the perceiver from the perception, but both have become one"; and "he who is sunk in this perception is no longer individual."[23] Such perception or "sensuous contemplation" "in every sense is wholly disinterested."[24] Schopenhauer explains this phenomenon by describing it in terms of the categories of his metaphysics.

[23] *The World as Will and Idea*, R. B. Haldane and J. Kemp, trans. (London, 1891), vol. 1, p. 231.
[24] *Ibid.*, p. 242.

Ordinarily we view things in relation to the will, as tools or possible tools for realizing the interests of the will. On occasion we may not be dominated by the will and are thereby free to contemplate the things we see as instances of Platonic ideas. On such occasions, the perceiver becomes a "pure will-less subject of knowledge," and this is what it means in Schopenhauer's theory to be disinterested. Also, on such occasions, the thing perceived by the pure subject "becomes . . . the *Idea* of its species."[25] Thus aesthetic contemplation has a subjective pole and an objective pole.

Having worked out his account of aesthetic contemplation, Schopenhauer then deals with the stock question of the nature of beauty. "When we say that a thing is *beautiful*, we thereby assert that it is an object of our aesthetic contemplation."[26] Thus a certain kind of state of consciousness determines beauty, and, therefore, Schopenhauer holds a strong version of the aesthetic-attitude theory. But it must be remembered that aesthetic contemplation for Schopenhauer always involves a certain kind of object—a Platonic idea—so his theory perhaps seems to be tied to a specific feature of the world in the way that theories of taste are. The theory is tied to Platonic ideas, but not to any particular one. As Schopenhauer puts it, since "everything is the expression of an Idea; it follows that everything is also *beautiful*." [27] That is, anything may become an object of aesthetic contemplation, and may, therefore, be beautiful. Since for Scho-

[25] *Ibid.*, p. 232. [26] *Ibid.*, p. 270. [27] *Ibid.*, p. 271.

penhauer, Platonic ideas place no restriction on the operation of aesthetic contemplation, for him aesthetic contemplation determines the beautiful. He therefore holds a strong version of the aesthetic-attitude theory. Schopenhauer's view may be contrasted with Shaftesbury's Platonic theory which is more like the theories of taste in that it makes the specific Form of Beauty the object of contemplation. Schopenhauer's theory places no specific restriction on what can be the object of aesthetic contemplation.

For better or for worse with Schopenhauer a point has been reached where it is no longer a question of the origins of the aesthetic-attitude theory, for his view is already an instance of that theory. His view, minus its metaphysical commitment to Platonic ideas and the will, is in many ways similar to that of such present-day aesthetic-attitude theorists as Edward Bullough, Eliseo Vivas, and Stolnitz. Nevertheless, as we shall subsequently see, these three present-day theorists hold weak versions of the aesthetic-attitude theory.

3

Individual and Social Powers: Basic Categories

The background of the concept of the aesthetic has been sketched out in Chapter 2. In this chapter I prepare the way for a discussion of the present-day aesthetic-attitude theories.

First, in order to lay the groundwork for analyzing taste and aesthetic theories, I shall distinguish between individual powers and activities and institutional powers and activities. It is not necessary for my purposes to give a complete account of such powers, and I shall not try to do so; it is sufficient to have a general idea of individual and institutional powers in order to see how they contrast with one another.

Second, I shall try to show that both the philosophies of taste of the eighteenth century and the aesthetic-attitude theories of the nineteenth attempt to deal with their basic problems in terms of individual powers and activities.

Third, in order to prepare the way for a discussion of the conception of aesthetic object in aesthetic-attitude

theories, I shall briefly discuss the aspects of works of art and their settings.

Fourth, I shall show that present-day aesthetic-attitude theorists follow the earlier tradition and conceptualize aesthetic objects in terms of individual powers and activities.

The power to discriminate a particular color in a visual field, to feel pleasure or pain, and to be hungry are examples of what I am calling individual powers. Examples of individual powers involving overt behavior are the power to run, to walk, to scream. Some, such as the power to walk, are ordinarily exercised voluntarily, while others, for instance the power to discriminate a color, are not voluntary; given certain conditions the power automatically functions. Briefly, these powers are abilities that individuals possess simply as a result of the nature of their bodily structures (or mental structures if there are independent mental structures). Of course, the development of many individual powers in human beings (but not in all animals) cannot occur except within a social structure because of the helplessness of human infants, but the basis of powers is physiological (or mental) structure. The examples mentioned thus far are powers that single individuals can exercise, but more than one person may be involved in an activity made up entirely of the exercise of individual powers. For example, if two men fight solely for the possession of a piece of food, the fighting involves only the exercise of individual powers. If, however, two men fight to win a laurel wreath, they are engaging in a contest and not only are individual powers

being exercised, the men are participating in social or institutional behavior. Fighting may be simply an individual activity or it may be an institutional activity, depending upon how the participants understand their behavior. The same can be said of running and many other activities. Compare the individual activity of running with the institutional activity of racing. Racing is done according to rules and restrictions; running is subject only to physical and physiological constraints.

Thus far I have spoken of individual activities and powers, but in regard to institutions I have mentioned only activities. Institutional powers are generated by institutional structures and activities. For example, the institution of racing generates, among others, the power to declare a winner, a power usually delegated to some particular persons—the timers. Umpires, parents, police officers, judges, teachers, legislators, all exercise institutional power at particular times. The artworld discussed in Chapter 1 is an example of an institutional structure which generates the power to confer the status of art. Such a power is of course an institutional one. In sum, it can be said that individuals as individuals have certain powers, the exercise of which results in individual activities. Institutional groups also have certain powers, the exercise of which results in institutional activities. The power of an institution is exercised through the individuals who act on its behalf. Institutions range all the way from official establishments with highly organized and defined procedures such as the state to rather loosely organized groups such as the artworld. Again without try-

ing to give a complete characterization, it can be said that institutional powers are capacities that individuals possess as a result of their position in a social organization. Individual powers derive from bodily (or mental) structures, and institutional powers derive from social structures.

I shall now briefly recall features of the theories of three of the philosophers—Hutcheson, Kant, and Schopenhauer—discussed in Chapter 2, in order to illustrate that eighteenth- and nineteenth-century theories are founded on the concept of individual powers. Hutcheson's view serves as an example of the British philosophy of taste; he tries to solve the problem of explaining the experience of beauty by arguing that human beings have a sense of beauty that reacts to a certain kind of perceived object. He calls the faculty of taste a "sense" not because it has a cognitive function (it does not) but because he conceives of it as a mental mechanism that reacts immediately, involuntarily, and instinctively, and is therefore disinterested. The point to be emphasized here is that the central feature of Hutcheson's theory is his contention that individuals have a native (God-given) power (not necessarily used or developed), the function of which explains what people undergo when they experience beauty. Hutcheson's sense of beauty, if it existed, would be an instance of an individual power.

Kant continues the reliance on the concept of individual powers to explain the experience of beauty; instead of a sense reacting and producing pleasure, however, he maintains that pleasure is produced by the cognitive faculties reacting in a certain way (free play). Thus for

Kant the functioning of an individual's cognitive powers explains the experience of beauty. Schopenhauer, as noted earlier, shifted away from the five-element pattern of the philosophy of taste, but he still attempts to explain the experience of beauty in terms of an individual power—aesthetic consciousness. Whatever is the object of aesthetic consciousness is, he says, beautiful.

Despite the methodological differences separating the British and German philosophers, a common tradition for explaining the experience of beauty in terms of the powers of individuals can be discerned. All of these philosophers assumed that some "original equipment" of individuals—a special sense, the cognitive faculties, a specific aesthetic consciousness—has an essential role in producing the beauty that people experience. The British philosophers thought that empirical psychological inquiry would reveal the nature of the power. The German philosophers did not conceive of their inquiry as an empirical one, but they did think they could arrive at conclusions about the nature of the individual's power to experience beauty.

Before discussing the aesthetic-attitude theory, which has replaced the notion of beauty with the notion of aesthetic object, it will be useful to consider works of art, their settings, and other relations from the point of view of the perception of them. Perception or related notions play a central role in the aesthetic-attitude theorists' conception of aesthetic object, so if the relation of perception to the various aspects and relations of art can be spelled out, the way will be prepared to understand this

theory. The distinctions made here about the aspects of works of art and their settings will also be useful when Monroe Beardsley's theory of aesthetic object is discussed in Chapter 7.

At this point I shall illustrate various aspects of works of art and their settings by talking about theater plays. Later, when it becomes necessary, discussions of other arts will be introduced. Some aspects of plays and their settings can be perceived from "a theater seat," that is, in the normal way during a performance. Examples of this category are actions of a character (for example, Hamlet's slaying of Polonius), the stage curtains, the property man in traditional Chinese theater (who performs his duties on stage among the actors during the performance). Some aspects of plays or their settings are not possible objects of perceptual attention from a theater seat, although they can be perceived from other locations, for example, the action of a stagehand in moving a piece of scenery behind a closed curtain and the wire (invisible to the audience) which "flies" Peter Pan through the air. Some aspects or at least relations of plays can never be objects of perceptual attention, such as the intentions, feelings, and mental images of the artist who writes the play.

The following list shows a number of the items involved:

1. Possible Objects of Perceptual Attention from a Theater Seat
 Characters

 Characters' actions
 Actors' performances
 Objects on stage
 The curtains
 The Chinese property man
 Stagelights
 Backs of spectators' heads
 Feelings of hunger of spectator

2. Objects Impossible of Perceptual Attention from a Theater Seat

 A. Perceivable from Other Locations
 Peter Pan's wire
 Stagehand's actions
 Director's actions
 Artist's writing of the play
 B. Never Perceivable
 Artist's intention, feeling, and mental images

However one wishes to treat items under 2B (the intention of the artist, etc.), it is clear that the items under 1 and those under 2A are in need of further sorting. For example, a character's action and the curtains belong to different domains. Present-day theories must come to grips with this problem of classification.

Turning now to present-day thinkers, I shall be concerned with those philosophers who perpetuate the tradition of the nineteenth-century aesthetic-attitude theories. Both the theories of taste and the nineteenth-century aesthetic-attitude theories were concerned to describe what goes on in the subject when he experiences beauty

and to explain why some men attend to the beauties of nature and art and some do not. Both kinds of theory assumed that such explanations are to be given in terms of the individual powers of men. Kant had focused attention on the individual cognitive powers as being relevant to explanation, and as we have seen, the influential Schopenhauer developed an aesthetic-attitude theory that cast the explanation purely in terms of perceptual and cognitive powers. According to the nineteenth-century aesthetic-attitude theories, the men who attended to the beauties of nature or art were doing so because they were exercising a certain kind of perceptual power and the men who did not attend were not exercising the power. The theoretical task was to describe the power; the practical task was to exhort men to develop and exercise it.

Persons who held a strong version of the aesthetic-attitude theory thought that exercising the power not only allowed the exerciser to attend to the beauties of nature and art, but that exercising the power helped to reveal these beauties by being in some way constitutive of the beauties. This imposing of features on the objects of experience is the heritage of Kant's epistemology or perhaps of Kant's epistemology as it was traditionally understood. Edward Bullough in 1912, at the beginning of what I am designating the present-day period, says not only that psychical distance is a component of aesthetic consciousness, but that it is the "criterion of the beautiful."[1] Something that is merely agreeable (by which Bul-

[1] " 'Psychical Distance' as a Factor in Art and an Aesthetic

lough means related positively to interests of the self) becomes beautiful when experienced while "distancing." Beauty is revealed and in some way and some degree constituted by the exercising of a certain power. Consequently, the object of experience may have, if Bullough's theory is correct, one kind of characteristics (agreeable ones) when experienced while not exercising the power of psychical distance and another kind (beautiful ones) while it is being exercised. This passage makes it sound as if Bullough held a strong version of the aesthetic-attitude theory, and perhaps he was influenced to a degree by that version, but see Chapter 4 for further discussion of this point. Recent attitude philosophers rarely speak of the beauties of nature or art but rather of aesthetic qualities or characteristics.

Later I shall argue that the aesthetic attitude does not occur, but even if it did, it could not accomplish in certain kinds of cases one of the tasks that attitude theorists assume it does. Aestheticians generally, including the attitude theorists, have sought to distinguish what are usually called the aesthetic characteristics of works of art from their nonaesthetic characteristics. For example, Monroe Beardsley, who is not an attitude theorist, tries to distinguish the perceptual and aesthetic qualities of works of art from their physical and nonaesthetic qualities.[2] The aesthetic qualities of a work of art constitute what is generally called "an aesthetic object." The ques-

Principle," reprinted in *Aesthetics*, E. M. Wilkinson, ed. (Stanford, Calif., 1957), p. 96.

[2] See Chapter 7 for a discussion of Beardsley's theory.

tion is, then, which characteristics of a work of art constitute the aesthetic object of that work and which characteristics do not. The point of settling the question is that aesthetic objects are the proper objects of appreciation and criticism, and aestheticians have wanted to make sure that appreciators and critics attend to the properly aesthetic characteristics of works of art. The aesthetic-attitude theorists' conception of aesthetic object is supposed to perform the function of separating the aesthetic characteristics of art from the nonaesthetic—as Virgil Aldrich says, by revealing "the aesthetic characteristics of things [in this case the things are works of art]."[3] The attitude theorists' definition of "aesthetic object" is "anything which is the object of the aesthetic attitude." Because, however, it is also held that anything can be the object of the aesthetic attitude, it is hard to see how in some cases the operation of the aesthetic attitude can do the required job of separating the aesthetic characteristics of art from the nonaesthetic. The blanket inclusiveness of their definition of "aesthetic object" precludes its being of help in some cases in separating those aspects of works of art which we ought to attend to from those we ought to ignore. Consider, for example, the case of the property man in traditional Chinese theater who, as mentioned earlier, performs his duties on stage during the performance. If one were to assume the aesthetic attitude at such a play, how would one not assume that attitude toward the Chinese property man (or the back of the head of the

[3] *Philosophy of Art* (Englewood Cliffs, N.J., 1963), p. 8.

person sitting in the seat ahead, for that matter). If the aesthetic attitude was assumed with respect to the Chinese property man, then the attitude would not help distinguish the aspects of the work of art that ought to be the objects of appreciation and criticism from those aspects that ought not to be. If the attitude theorist says that the Chinese property man is antecedently known not to be included in the aesthetic object and that the aesthetic attitude is not directed at him and his activities, then the aesthetic attitude does not reveal that an actor's performance is part of the aesthetic object of the play and the property man's performance is not. Indeed, the operation of the aesthetic attitude alone cannot exclude anything perceivable from a theater seat (the backs of spectators' heads, the stage curtains, etc.), since the aesthetic attitude allegedly can be taken toward anything.

There is another kind of case, however, in which the operation of the aesthetic attitude (if it did occur) would apparently accomplish the task of separating aesthetic characteristics from nonaesthetic ones. Consider an example that Virgil Aldrich gives of a nonaesthetic characteristic of a painting, namely, "the deployment of colored pigments on the canvas."[4] No doubt he means to contrast seeing that the colored pigments are spaced a certain distance apart with seeing that the pigments constitute a certain design, say, a circular or a spiral one. Aldrich apparently wishes to conclude that the simple, spatial deployment of the pigments which is seen when

[4] "Back to Aesthetic Experience," *Journal of Aesthetics and Art Criticism*, Spring 1966, p. 367.

one looks at the painting while not being in the aesthetic attitude is "transformed" into a design when one looks at the painting while in the aesthetic attitude. This is a rather different kind of "separating" of characteristics than occurs with the Chinese property man and similar cases, and it does not seem to raise the difficulties of those cases. In Aldrich's case the pigments are allegedly transformed by the operation of the aesthetic attitude into what everyone would admit is an aspect of an aesthetic object, namely, a design.[5] In the previous cases, however, the difficulty was that the aesthetic attitude would be taken toward the Chinese property man and stage curtains, which clearly are not aspects of the aesthetic object of a play. If, however, the difficulty of the aesthetic attitude's failure to exclude things which obviously are not aspects of aesthetic objects is not raised by the "transformation" of the deployed pigments into a design, it and all cases like it allegedly depend on the operation of the aesthetic attitude which supposedly accomplishes the "transformation." The important question becomes, then, "Is there an aesthetic attitude?" I shall attempt to answer this question by examining three versions of the aesthetic-attitude theory in the following three chapters.

[5] I am not agreeing that the deployed pigments are non-aesthetic.

4

Psychical Distance: In a Fog at Sea

In this chapter and the two that follow, I shall discuss the three distinct present-day versions of the aesthetic-attitude theory: Edward Bullough's theory of psychical distance, Jerome Stolnitz's and Eliseo Vivas' more recent theory of disinterested attention, and Virgil Aldrich's even more recent theory of aesthetic perception.[1] I shall try to show that there is a fundamental flaw in each version.

The 51 years between the publication of Bullough's and Aldrich's theories is a considerable period of time, and this gap is reflected in the fact that Bullough's language and assumptions are rather close to those of Scho-

[1] See Edward Bullough, " 'Psychical Distance,' as a Factor in Art and an Aesthetic Principle" reprinted in *Aesthetics*, E. M. Wilkinson, ed. (Stanford, Calif., 1957), pp. 91–130 and elsewhere; Jerome Stolnitz, *Aesthetics and Philosophy of Art Criticism* (Boston, 1960); Eliseo Vivas, "Contextualism Reconsidered," *Journal of Aesthetics and Art Criticism*, December 1959, pp. 222–240; and Virgil Aldrich, *Philosophy of Art* (Englewood Cliffs, N.J., 1963), pp. 19–27.

penhauer, while Aldrich casts his theory in the language of Wittgenstein. Throughout this time span and despite the shifts of philosophical fashion, the central feature of the attitude tradition—the alleged importance of a specific state of mind for the experience of the aesthetic—has persisted. Despite the long period of time and large number of people working in the attitude tradition, I think the three versions selected for discussion are representative of the present-day forms of the theory.

Several theories at the turn of the century resemble Bullough's (Ethel Puffer's slightly earlier theory, for example), but his often reprinted account of psychical distance has been by far the most influential. Later attitude theorists either adopted Bullough's theory or saw their own as developing from it.

Bullough conceives of psychical distance both as one of the essential elements of what he calls "aesthetic consciousness" and as a criterion of the beautiful.[2] Psychical distance is supposed to be a psychical component of a specific kind of consciousness which when "inserted" between a subject and his affections is productive of aesthetic experience. As Bullough puts it, aesthetic experience is "due—if such a metaphor is permissible—to the insertion of Distance."[3] It is this act of "inserting" that attitude theorists presumably have in mind when they speak of people distancing some object or occurrence. Being psychically distanced is the psychological state, partially constitutive of "aesthetic consciousness," into

[2] " 'Psychical Distance,' " p. 96.
[3] *Ibid.*, p. 94.

which one is placed by an act of distancing or into which one is induced without an act of distancing by the properties of an object or occurrence. Bullough thinks that distancing is a kind of voluntary action; his present-day follower, Sheila Dawson, reads him that way and says that critics, actors, and members of orchestras "distance deliberately."[4] Presumably, persons who frequently experience art are capable of doing the act of distancing, and, of course, all persons who have aesthetic experience, according to the distance theorists, will be in the state of being psychically distanced during the experience.

Bullough analyzes the working of distance into two elements: "It has a *negative*, inhibitory aspect—the cutting-out of the practical sides of things and of our practical attitude to them—and a *positive* side—the elaboration of the experience on the new basis created by the inhibitory action of Distance."[5] The first aspect of distance is a psychological blocking of ordinary, practical actions and thoughts which is necessary for the positive side of distance, i.e., the experience of something as an object of aesthetic consciousness. The assumed necessity of the blocking comes out clearly when Bullough says that "by putting [an object] out of gear with practical needs and ends . . . the 'contemplation' of the object becomes alone possible."[6] There seems to have been a persistent belief among aestheticians that people are so concerned

[4] " 'Distancing' as an Aesthetic Principle," *Australasian Journal of Philosophy*, August 1961, p. 158.
[5] " 'Psychical Distance,' " p. 95.
[6] *Ibid.*, p. 96.

with "the reality of things" that they cannot appreciate the qualities of things unless their concern is somehow blocked. When the objects being experienced are works of art the belief takes the form of the persistent fear that people will mistake art for reality or will somehow entangle themselves with the art unless a specific kind of psychological process blocks them from doing so. I. A. Richards' bizarre account of what keeps a spectator in his seat at a performance of *King Lear* is a good illustration of an explanation (in this case a behavioristic one) based upon this persistent belief and fear. Richards claims that a spectator feels pity and fear for Lear, that pity is an impulse toward Lear and fear an impulse away from Lear, and that the opposition of the impulses balances out and prevents the spectator from either taking action to help Lear or from fleeing the theater.[7] Psychical distance plays a similar role for Bullough, except that instead of ordinary impulses balancing one another as in Richards' account, distance is supposed to be a special psychological force that blocks the ordinary impulses. Ethel Puffer, whose theory is closer to Bullough's in both time and nature than Richards', characterizes her version of aesthetic detachment as hypnosis. She says that her theory, "if accepted, would constitute a theory and a definition also of hypnotism."[8] For Puffer, and I think for Bullough

[7] *Principles of Literary Criticism* (London, 1925), pp. 245–246. For a discussion of Richards' theory, see my "I. A. Richards's Phantom Double," *British Journal of Aesthetics*, January 1968, pp. 54–55.

[8] *The Psychology of Beauty* (Boston, 1905), p. 84.

also, a spectator is "hypnotized," either by "self-hypnosis" or by an object, into a state of mind deemed necessary for aesthetic appreciation.

Although Bullough explicitly says that distance has both negative and positive aspects, the alleged negative and inhibitory psychological force has come to be identified as psychical distance. Bullough himself devotes all of his attention to distance as an inhibitory force, and what he at first calls its positive aspect in effect becomes that which can happen after distance (the inhibition) occurs.

There is, however, more to Bullough's theory. Just as people can be more or less hungry, more or less tired, more or less happy, Bullough thinks people can be more or less distanced. "Distance," he writes, "may be said to be variable both according to the distancing-power of the individual, and according to the character of the object."[9] Ideally, according to Bullough, it is most desirable to attain "the utmost decrease of Distance without its disappearance."[10] Distance can be lost by its decreasing to the limit of the power of a particular person—he calls this "under-distancing"—or by a person having "an excess of Distance"[11]—he calls this "over-distancing." Bullough's theory has been criticized in a minor way by some who think he should not speak of distance as varying by degrees, but rather of a person either having distance or not having it.[12] I believe, however, that the theory is subject

[9] " 'Psychical Distance,' " p. 100.
[10] *Ibid.*
[11] *Ibid.*
[12] By myself some time ago in "Bullough and the Concept of

to a much more fundamental criticism which I will make later.

Bullough attempts to illustrate the functioning and the failure to function of psychical distance with several hypothetical cases. The alleged example of distancing and of being distanced with which he begins his famous article actually puts his theory in the best possible light. Although an unwary reader might not realize it, the hypothetical person in Bullough's example finds himself in a rather desperate and atypical situation. What is needed is a more typical case illustrating distance. Distance in a typical case of aesthetic experience would be generalizable, whereas even if distancing and being distanced occurs in a desperate and atypical case it might not be generalizable. Bullough asks us to imagine ourselves in a fog at sea, and he then details the dangers and anxieties of the situation. Despite the dangers, such a fog, he thinks, can be a source of great aesthetic enjoyment. He writes:

Abstract from the experience . . . for the moment, its danger and practical unpleasantness, . . . direct the attention to the features "objectively" constituting the phenomenon—the veil surrounding you with an opaqueness as of transparent milk. . . . This contrast, often emerging with startling suddenness, is like a momentary switching on of some new current, or the passing ray of a brighter light, illuminating the outlook upon perhaps the most ordinary and familiar

Psychical Distance," *Philosophy and Phenomenological Research*, December 1961, pp. 233–238, and more recently by Allan Casebier in "The Concept of Aesthetic Distance," *The Personalist*, Winter 1971, pp. 70–91.

objects—an impression which we experience sometimes in instants of direst extremity, when our practical interest snaps like a wire from sheer overtension, and we watch the consummation of some impending catastrophe with the marvelling unconcern of a mere spectator.[13]

I do not have any real quarrel with the description of the hypothetical phenomenon; it seems relatively plausible. But Bullough's theoretical explanation of the phenomenon requires examination. He explains "the shift of attitude" by "the insertion of Distance," which transforms a person's experience. He writes, "Thus, in the fog, the transformation by Distance is produced in the first instance by putting the phenomenon, so to speak, out of gear with our practical, actual self."[14] Bullough's explanation is similar to Schopenhauer's account of the sublime in which he speaks of the forcible detachment of the will necessary for appreciating a threatening object, except that Bullough's theory is supposed to apply to all aesthetic experience, not just the threatening sublime.

Bullough gets his theory off to a fast start by using an example of an actual threatening phenomenon. It seems initially plausible in such a case to think that a psychological force is needed to block our practical concerns for safety in order to aesthetically appreciate what is threatening. Bullough then turns to a discussion of psychical distance as it supposedly functions in the appreciation of art. In the drama, the characters, he says, "appeal to us like persons and incidents of normal experience,

[13] " 'Psychical Distance,' " p. 94.
[14] *Ibid.*, p. 95.

except that that side of their appeal, which would usually affect us in a direct personal manner, is held in abeyance."[15] Most people, he notes, explain the holding in abeyance as the result of knowing the characters are fictional, but he denies that this is correct. He maintains that "Distance, by changing our relation to the characters, renders them seemingly fictitious, [it is] not . . . the fictitiousness of the characters [which] alters our feelings toward them."[16] Here is a clear instance of the fear that art is always in danger of being confused with reality and the consequent felt need for a psychological force to prevent the mistake. Bullough attempts to illustrate how the aesthetic appreciation of art can fail because of "under-distancing" and how it can occur when a person is properly distanced. Both of the hypothetical cases involve a jealous husband at a performance of *Othello*. On the one hand, his jealousy may cause him to lose distance; "by a sudden reversal of perspective he will no longer see Othello apparently betrayed by Desdemona, but himself in an analogous situation with his own wife."[17] On the other hand, the jealous husband can appreciate the play if he can maintain distance, although that, Bullough remarks, will be very difficult.

Another hypothetical case frequently used to illustrate "under-distancing" is that of a spectator who loses distance and runs onto the stage to attack the villain and save the heroine. Bullough himself does not use this kind

[15] *Ibid.*, p. 97.
[16] *Ibid.*, p. 98.
[17] *Ibid.*, p. 99.

of case to illustrate his theory, but given his view that a spectator's being in a state of psychical distance makes the stage characters seem fictitious to that spectator, it is perfectly plausible that if a spectator's being in a state of psychical distance ceased, he might (if the spectator were also chivalrous) attack a stage villain. This case is different from the fog and *Othello* cases since in them only thoughts supposedly are blocked or not blocked, whereas in the attacker-spectator case action supposedly is blocked (when the spectator is in a state of psychical distance) or not blocked (when he is not in that state).

The *Othello* cases and the attacker-spectator resemble the fog case in that they too are desperate ones: in the first, the enraged husband either loses distance and is not able to appreciate the play because plagued by jealous thoughts or is able to appreciate it only while struggling to maintain the necessary psychological state that suppresses the jealous thoughts, and in the second, the spectator loses distance and takes action. In both the *Othello* cases and the attacker-spectator case it also seems initially plausible to think that a psychological force is required to suppress the husband's jealousy and the spectator's impulse to assist the heroine. But even if a psychological force were required in such cases, the enormous majority of cases of the appreciation of art and nature are not desperate cases. Usually when we watch a play, look at a painting, listen to music, or gaze at natural scenery and appreciate them, there is no hint of impulses to action which have to be overcome. Nor do real-life emotions such as jealousy and fear constantly occur and require

blocking out. In Bullough's view, however, in order to have aesthetic experience we constantly have to overcome by distancing some practical impulse to action such as to join the actors on the stage or to plow the scenery into farmland or some practical emotion like jealousy or fear. Bullough has taken several atypical cases of aesthetic appreciation, has tried to show that these desperate cases necessarily involve the occurrence of a psychological blocking force, and then has concluded that such a force is necessary for every case of aesthetic appreciation. But if one reverses Bullough's procedure and begins with "easy" cases, with the experience of works devoid of strong emotional content, then the idea that *all* aesthetic experiences require insulation from practical impulses and thoughts simply does not arise. Of course, even with the reversed procedure, someone might go on to conclude that desperate cases require the occurrence of distancing. But at least this weaker conclusion would show that "being distanced" is not a necessary condition for aesthetic appreciation.

Is there, however, any evidence that acts of distancing and states of being distanced ever actually occur in connection with our experience of art and nature? When the curtain goes up, when we walk up to a painting, or when we look at a sunset, do we ever commit acts of distancing and are we ever induced into a state of being distanced? I cannot recall committing any action that suspends practical activities or being in a psychological state that prevents practical activity. But the issue does not need to be decided on introspective evidence alone. Consider the

case of the attacker-spectator in the theater. Distance theorists present his attack on the stage villain as merely a resumption of his ordinary, practical activity. They see his action as the same kind of behavior as having dinner, walking to the theater, helping an old lady across the street, and subduing a man engaged in robbing someone. But to regard all these instances of behavior as of the same type is clearly wrong. For example, his subduing of the robber is a sane and praiseworthy action, but his attack on the stage villain, assuming him to be a frequent theater-goer, is just insane. To regard the attack as *simply* the resumption of practical activity is a great confusion; such behavior would be deranged. In fact, there is no appropriate way for a spectator to behave practically in the usual theater situation, unless one counts applauding and keeping quiet as practical activity. When one enters a theater, one does not have to act to suspend practical matters or be gotten into a state of mind in which impulses to action are suppressed, because watching plays is just not a practical activity to begin with, and any knowledgeable person in his right mind knows it. As Samuel Johnson says of watching plays, "The truth is, that the spectators are always in their senses, and know, from the first act to the last, that the stage is only a stage, and that the players are only players."[18] It cannot be true, as the distance theorists would have it, that a psychological force which had been operating within the man who

[18] In Walter Raleigh, *Johnson on Shakespeare* (London, 1950), p. 27.

later becomes the attacker and all the other members of the audience to restrain them all has suddenly ceased in the case of the attacker, and that he has begun to act in a practical way. Rather the attacker-spectator would have ceased to act in a perfectly usual manner (watching a play) and would have begun to act very oddly. He would not be behaving practically, but insanely.

Even in cases such as being in a fog at sea in which actual, practical dangers exist and in which we may be in a position to act practically, we are not, when we appreciate the qualities of the fog, restrained by a psychological force which "cuts out the practical side of things." If we appreciate some of the qualities of a fog at sea, we do not cease to be aware of the associated dangers (if we were aware of them to begin with), and we are or may be ready to act if the need arises and we know what to do. We may not at every moment while appreciating the qualities of the fog be thinking of the dangers, but this is not because the thought of the dangers has been removed by a special act or state of mind. The failure of the jealous husband at *Othello* to appreciate the play does not show that there is a case of someone who has lost or failed to achieve being psychologically restrained either. Later I shall try to give rather extensive descriptions of what I take to be actually going on in the *Othello* case and others which have been discussed. There does not, then, seem to be any real evidence to support the conclusion that acts of distancing or states of being distanced as described by Bullough and his followers really

occur. In fact, reflection suggests that such acts and states do not occur in connection with our experience of art and nature.

If the distance theorists were simply asserting the existence of nonexistent acts and states, it would be bad enough. But their belief in the occurrence and necessity of psychological forces to restrain spectators causes them to have a distorted view of the experience of art, which in turn causes them to draw unwarranted normative conclusions about certain aspects of certain works of art. In addition, their belief in the existence of a special psychological state controlling the behavior of spectators conceals from them the fact that institutional conventions govern the behavior of spectators.

Consider, for example, how adherence to the believed necessity of psychical distance for aesthetic appreciation distorts one theorist's view of a particular nondesperate case. Sheila Dawson writes of a well-known scene in the play *Peter Pan:*

One remembers the horrible loss of distance in Peter Pan— the moment when Peter says, "Do you believe in fairies? . . . If you believe, clap your hands!", the moment when most children would like to slink out of the theatre and not a few cry—not because Tinkerbell may die, but because the magic is gone. What, after all, should we feel like if Lear were to leave Cordelia, come to the front of the stage and say, "All the grown-ups who think that she loves me, shout 'Yes'."[19]

[19] " 'Distancing,' " p. 168.

But it is simply false to say that Peter Pan's appeal causes distress to the children in the audience, and only a person in the grip of a theory could come to believe that it does; in fact, the children respond enthusiastically to what for them is a dramatic highpoint. The playwright gives the audience a momentary chance to be a force in the play and the children accept it. The only reported case that I know of of a child being distressed by Peter Pan's request for applause is that of Susanne Langer as a child. Langer reports that as a child the appeal shattered the illusion of the play and caused her misery.[20] Perhaps it did cause her misery, but perhaps she is remembering the event through the filter of her own theory which resembles Bullough's. But more important than whether the young Susanne Langer was miserable or not, she reports that all the other children present clapped and laughed and enjoyed themselves. If the responses of people, in this case children, are to be used to support a theory of the relation of spectators to works of art, we should follow the response of the overwhelming majority. Langer, however, is more interested in her own reaction as a child—which confirms her own theory—than that of all the other children. Nevertheless, Langer's remarks are less misleading than Dawson's because Langer at least supplies data about how children respond, whereas Dawson seems simply to deduce what the children's behavior would be from the theory of psychical distance. But Dawson is clearly wrong about children's behavior at *Peter Pan*, and she is

[20] *Feeling and Form* (New York, 1953), p. 318.

just as wrong in thinking that children are in a kind of hypnotic state before Peter Pan's appeal.

On the basis of a normative principle derived from the assumed necessity of psychical distance, Dawson is clearly trying to derogate from *Peter Pan* by comparing its appeal incident to a hypothetical one in *King Lear*. The comparison is at best pointless. *Peter Pan* is a magical play in which almost anything can happen, but *King Lear* is a play of a different kind. Even so, devices similar to that in *Peter Pan* have been used successfully in "non-magical" plays. For example, actors directly address the audience in *Our Town*, *The Marriage Broker*, *A Taste of Honey*, and many others without causing these plays to be less valuable than they would be otherwise.

The theorists of psychical distance in concentrating so much attention on the psychological powers of individual persons have mistaken the functioning of an institutional convention against spectators participating in *some* works of art for the functioning of a psychological force, the role of which is to prevent participation in all cases of aesthetic appreciation. Most theater productions, for example, are presented with the tacit assumption (the institutional convention) that the spectators do not participate in the action of the play or interact directly with the characters, but *Peter Pan* and many other plays are exceptions to the rule—they are presented under slightly different conventions. The conventions governing the behavior of spectators of art range all the way from dance situations where the line between spectator and dancer is blurred to the extent that spectators may be-

come dancers and dancers become spectators to the usual theater situation in which the distinction between actor and spectator is rigidly maintained and the role of the spectator is strictly defined. Between these extremes lie the cases already discussed and such things as hissing the villain and cheering the hero in old-fashioned melodrama and applauding during an act because of an especially good performance. There have been many innovations in works of art and in their presentation, and the innovations continue to be made. This means that the conventions governing the presentation of art must be altered from time to time. Of course, some people dislike any innovation, especially if they hold theories that dress up the most frequently used conventions as psychological forces essential for "aesthetic consciousness." We are not prevented from interacting with works of art by psychological forces within us, rather we are barred from interacting with many or most works by conventions governing particular art situations. Bullough's contention that such devices as picture frames and raised stages help to cause a psychological phenomenon restraining us from acting is wrong. Such devices serve, along with other purposes, as a signal (if any is needed) that a certain convention is to be observed. Other devices, such as Peter Pan's appeal or the Stage Manager of *Our Town* addressing the audience, serve to suspend the usual rule.

No special psychological force restrains spectators. What, then, are the correct descriptions of the "desperate" cases Bullough and his followers misdescribe? One possible explanation of a case in which a stage villain is

attacked is that the attacker-spectator has ceased adhering to the nonparticipation convention because he has become deranged. In this case the attacker-spectator first knows of the convention, but for certain psychological reasons "loses sight of it." The spectator's attention to the play has been interrupted by his sudden, deranged mistaking of the play for real life. In another possible case an attacker-spectator might never have known of the nonparticipation convention, being entirely unfamiliar with the theater and its conventions. In this case the spectator would never have attended to the play, that is, he would from the beginning have mistaken the play for real life. One could go on for some time spinning out possible explanations for cases of attacker-spectators but that is not necessary. What is important is that such an attack is not an instance of practical behavior but rather behavior which is bizarre either because it is insane or uninformed.

In the case of the fog at sea, a person can, as has already been shown, appreciate qualities of the fog without being psychologically restrained from practical concerns. In fact, a person might even attend to and appreciate the fog qualities at the same time that he takes practical *action* against the dangers that the fog brings about. A sailor, for example, might appreciate the sight of the "milky opaqueness" of the fog while securing lines, an activity so routine that he does not have to watch his hands as he does it. Or he might appreciate the sight of the fog and the feel of the dampness on his face as he peers from the bow looking for obstacles. Such examples

show that there is no necessary conflict between aesthetic appreciation and practical concerns. Of course, many practical actions would conflict with the appreciation of the fog because they require complete attention—for example, one cannot gaze at a fog and watch a radar screen at the same time. Also, some practical concerns might conflict with aesthetic appreciation in another way; for example, a person might be so terrified in a fog at sea that he could not appreciate anything. Ignoring for the moment all the other kinds of cases and concentrating only on the terrified traveler kind, it can be seen that terrified travelers are not gotten to appreciate the qualities of fog by having them voluntarily restrain their fears or by being put into a state in which their fears are hypnotically submerged. If, however, their fears can be allayed by the captain's display of confidence, or by being shown that the radar scope show no obstructions in the water, or by some other means which reassures that there is no danger, then perhaps the terrified travelers can be brought to appreciate the qualities of the fog. The terrified travelers do not require a special psychological force to restrain their fears, they require information indicating they have nothing to fear—then they would be able to focus attention on the qualities of the fog.

Consider the jealous husband at *Othello*. A jealous husband who fails to appreciate the play might fail to do so in several different ways. He might be an individual whose thoughts of his own personal situation simply distract him from attending to the play once it has reminded him of his problem. This kind of case is one Bul-

lough characterizes as being under-distanced. But the jealous husband has not been forced out of a special state of consciousness; his attention has just been distracted from one thing (the play) to another (his musings about his wife). The jealous husband is not in a special psychological relation to the play in this case; he is just not attending to it. Inattention is not a special kind of attention. In a second kind of case which Bullough would also classify as being under-distanced, a jealous husband might fail to appreciate *Othello* because, although he continues to attend to the action of the play, it makes him miserable since his own personal situation makes him abnormally sensitive to portrayals of jealousy. At this point I want to make clear that the word "appreciation" has several distinct meanings and that speaking simply of the appreciation of *Othello* may mask some important distinctions. In this second case, the husband can appreciate *Othello* in the sense of fully understanding it and in the sense of finding it valuable, but he does not appreciate it in the sense of finding it enjoyable or pleasant. There are further ambiguities to be discerned in "enjoyable" and "pleasant," but it is not necessary for my purposes to do so. Much of the great art we appreciate so keenly is not pleasant in the relevant sense. So the jealous husband can appreciate *Othello* without finding it pleasant. In fact, his appreciation of the play may be keener than that of someone who has a more serene domestic life. Of course, a jealous husband might find *Othello* so painful that his attention to it would be blocked out entirely or that he would leave the theater. In this eventuality, he could not

appreciate the play in *any* sense because he could not attend to it, and he would be in a situation similar to that of the first case.

In a third and quite different kind of case, a spectator at *Othello* might fail to appreciate the play because although he more or less attends to the action of the play, he constantly views the play either in relation to some real or imagined historical prototype, some social problem, or some other thing "external" to the play. These kinds of cases are called instances of "over-distancing" by Bullough and his followers. "Aesthetic consciousness," according to distance theorists, is destroyed in these kinds of cases by a concern with things outside the work of art in question. I think distance theorists greatly exaggerate the pernicious effects on appreciation of concerns with things external to works of art. This exaggeration is due to their imagining that appreciation requires being in a special mental state so delicate that the least external pressure destroys it. We almost always have, however, a background awareness of something external to a work we are appreciating. In this sense of awareness we recognize Othello's actions as jealous behavior of a kind we meet with in real life, we recognize a visual design as a representation of a man or as a portrait of a particular man, and so on. There also are momentary distractions such as coughing in the audience, the hardness of the theater seat, questioning thoughts of whether the stove got turned off at home, noticing the color of the stage curtains, and so forth. Neither the background awareness nor the momentary distractions necessarily interfere with

appreciation. Concerns with external things could distract a spectator completely or substantially from a work of art. In such cases, the correct thing to say is that the spectator's attention has been distracted from the work to such an extent that he is unable to appreciate it. A spectator is not in a special relation *to the work*—the relation of having over-distanced it—he is out of relation to the work, that is, he is wholly or partly not attending to it.

Allan Casebier has recently attempted to defend what he takes to be a restricted version of Bullough's notion of distance.[21] Casebier presents some hypothetical examples of the viewing of the movie *Citizen Kane* which he regards as cases of being distanced and nondistanced. He cites as distanced viewing of the movie the case in which a spectator attends "to certain recurring themes— the identity of snow with naturalness, the mystery of Rosebud, the two-sided character of Kane."[22] The cases of distanced viewing, according to Casebier, involve the spectator's attending to what he calls "the internal qualities" of and "the internal relations" within the film, plus such "external relations" as can be attended to without distracting from the film. By the way, Casebier is very careful not to exaggerate the pernicious effects on appreciation of attention to external concerns. Examples of the hypothetical nondistanced instances he mentions are: (1) a case in which a spectator "focuses his attention predominately on the historical accuracy of the film's portrayal of American life in the first half of the twen-

[21] "The Concept of Aesthetic Distance," pp. 70–91.
[22] *Ibid.*, pp. 74–75.

tieth century," and (2) a case in which the spectator is a
filmmaker who "focuses his attention on . . . the rela-
tions of the visual and auditory qualities of the film to
film-craft."[23] Casebier has many penetrating things to say
about spectators, their relation to movies, and the charac-
teristics of movies, but his conception of distance is
clearly different from Bullough's. He does not make the
mistake of speaking of special acts and states of mind or
of aesthetic consciousness. In fact, he explicitly states that
Bullough claims too much for his theory. Casebier's use
of the words "distanced" and "nondistanced" are just
ways of talking about attention and inattention to works
of art and about the internal and external aspects of art.
Since Casebier's remarks retain none of the objectionable
features of Bullough's theory, nothing further needs to
be said here about them.

To sum up, there is no reason to think that a psycho-
logical force to restrain either action or thoughts occurs
or is required in the ordinary, nondesperate cases of aes-
thetic experience—the cases which constitute the enor-
mous majority of such experiences. No such force occurs
or is required in desperate cases either. In desperate cases
which involve works of art, no restraining force to pre-
vent action occurs because, as Johnson says, we know
throughout that we are observing works of art. Also,
with desperate cases involving art, no restraining force to
prevent practical thoughts occurs either, we are either
just able to concentrate our attention on the work or

[23] *Ibid.*, pp. 73–74.

we are distracted from it in some way. In desperate cases which involve natural things, no restraining force to prevent action or practical thoughts occurs either. In a given case, we may or may not be able to concentrate our attention on the qualities of the natural thing, but no special kind of act or state of mind exists to suspend action or anxieties.

Is Bullough's view an instance of the strong version or the weak version of the aesthetic-attitude theory? When he speaks of distancing as a criterion of the beautiful and of the merely agreeable being transformed into the beautiful by distancing, it sounds as if he holds a strong version. Nevertheless, the theory he actually displays is clearly a weak version, a theory that presents distancing as a necessary condition for appreciating the qualities objects have independent of the distancing.

5

Aesthetic Attention: Disinterested Awareness

Many present-day aestheticians, although sympathetic to Bullough's general point of view, apparently hesitate to embrace the notion of a special kind of act or state of mind, the specific function of which is to make the aesthetic features of objects accessible. These aestheticians, whose theories may be understood as developments and refinements of Schopenhauer's as well as of Bullough's views, replace Bullough's special acts and states of mind with ordinary mental attributes functioning in special ways, namely, attention or perception functioning aesthetically. In some respects, the present-day view more closely resembles Schopenhauer's theory, which explicitly speaks of disinterested perception, than it does Bullough's. The view of the aestheticians who follow this line and who are discussed in this chapter may be called "the theory of aesthetic attention." As indicated earlier, I shall try to show that this second version of the aesthetic attitude is fundamentally mistaken.

Many philosophers of the present and recent past have

put forth theories of aesthetic attention. I have selected the theories of Jerome Stolnitz and Eliseo Vivas for analysis and criticism because they are typical, well known, and rather completely worked out. Stolnitz defines the aesthetic attitude as the "disinterested and sympathetic attention to and contemplation of any object of awareness whatever, for its own sake alone."[1] The notion of disinterestedness, which Stolnitz has elsewhere shown to be seminal for modern aesthetic theory,[2] is the key term here, and he defines "disinterested" as meaning "no concern for any ulterior purpose."[3] Consequently, the notion of disinterested attention requires examination. Vivas in effect characterizes the aesthetic attitude in his definition of aesthetic experience as "an experience of rapt attention which involves the intransitive apprehension of an object's immanent meaning and values in their full presentational immediacy."[4] Vivas' key term is "intransitive," and he makes clear what he means by it in a number of passages, but perhaps the following is the best for this purpose: "Having once seen a hockey game in slow motion, I am prepared to testify that it was an object of pure intransitive experience—for I was not interested in which team won the game and no external factors mingled with my interest in the beautiful rhythmic flow of the slow-

[1] *Aesthetics and Philosophy of Art Criticism* (Boston, 1960), pp. 34–35.

[2] "On the Origins of 'Aesthetic Disinterestedness,'" *Journal of Aesthetics and Art Criticism*, Winter 1961, pp. 131–143.

[3] *Aesthetics and Philosophy of Art Criticism*, p. 35.

[4] "Contextualism Reconsidered," *Journal of Aesthetics and Art Criticism*, December 1959, p. 227.

moving men."[5] Stolnitz's "disinterested attention" and Vivas' "intransitive apprehension" play the same role in the two versions of the aesthetic-attention theory: namely, the expressions designate the alleged individual power which when exercised makes accessible the aesthetic features of objects. Disinterested attention, which Stolnitz construes as not involving ulterior purposes, seems to fit some kinds of cases best, whereas intransitive apprehension or attention, which Vivas illustrates with the hockey game, seems most suitable to others. For example, disinterested attention seems to fit cases where it is possible for a spectator to have some ulterior purpose (such as to write a review), but in fact he does not; intransitive attention seems to suit cases where it is possible for a spectator to have a desire that something in particular happen (such as one team win), but in fact he has no such desire. The point is that having a purpose and having a desire are not exactly the same, although they are similar in that a spectator having either relates the object of his attention to some other thing—in the cases mentioned, either to an envisaged review or to a certain outcome of a game. It is the perceived relations or relationlessness of the objects of attention to things outside them and the alleged individual power controlling whether the object of attention is perceived as related or unrelated to things outside it that are the basic concerns of the aesthetic-attention theorists. The technical terms of one theory may not cover smoothly all the relevant cases, as just illustrated, so it is

[5] *Ibid.*, p. 228.

useful to have recourse to the technical vocabulary of both Stolnitz's and Vivas' versions of the aesthetic-attention theory.

The expression "disinterested attention" can have meaning only if it makes sense to speak of "interested attention." In order disinterestedly to attend to (look at) paintings, one must be able interestedly to attend to them; in order disinterestedly to attend to (listen to) music, one must be able to attend interestedly; and so on. A similar pairing is required for intransitive attention. Let us now take a cast of three—Arthur, Marvin, and Zachary—through a series of examples of the kind theorists such as Stolnitz and Vivas use to illustrate the occurrence of interested and disinterested attention. Actually, the examples supposedly illustrate interested attention, and the reader is presumably to understand what disinterested attention is because it is the opposite of the illustrated interested attention.

Suppose that Arthur and Zachary are looking at a portrait of Zachary's father. Let us also suppose that, as will be supposed in all the hypothetical cases to be considered, Arthur's behavior and state of mind is everything that the aesthetic-attention theorists could desire in order to conclude that he is attending disinterestedly. Zachary, however, instead of noting and appreciating the color harmony, spatial organization, or expressive features of the representation, is simply reminded of his father and falls to musing or recounting tales about his father to Arthur. Zachary's behavior and state of mind would be characterized by aesthetic-attention theorists as an example of

attending transitively to the painting by using the work of art as a vehicle for associations, that is, as a case of attending with external factors in mind. But in this case Zachary is not attending to the painting at all, although he may be facing it with his eyes open. He is now attending to his musing or to the story he is telling, although he looked at the painting first and noticed that it was a portrait of his father. Zachary is not now attending to the painting transitively or interestedly, since he is not now attending to it at all. The object of Zachary's attention is either his memories of his father or the story he is telling, but neither of these is an aspect of the painting and, hence, his musing or telling cannot be correctly described as attending to the painting transitively or interestedly. In cases such as this one, what aesthetic-attention theorists are really noting is the occurrence of associations that *distract* a viewer from a painting. But being distracted from something is not, as they seem to believe, a special kind of attention to that thing; it is a kind of *inattention* to that thing.

Of course, the case of Zachary's inattention to his father's portrait does not settle everything, because there are supposed cases of interested attention that are not instances of sheer inattention. Let us now consider the case of Arthur and Marvin listening to a piece of music to which supposedly Arthur attends disinterestedly and Marvin interestedly. Marvin is listening to the music with the ulterior purpose of being able to analyze and describe it on an examination the next day, but Arthur listens to the same music with no such ulterior purpose. The first

thing to notice here is that what are supposed to be dif-
ferent ways of using an individual perceptual or atten-
tional power—attending disinterestedly and interestedly
—apparently turn out to be attending with different mo-
tives. That is, the aesthetic-attention theorists claim that
there are two ways of attending, namely, disinterestedly
and interestedly, but when their definition of "disinter-
ested" is substituted for the term into descriptions of
particular cases, it seems that "interested attention" means
attending with certain motives and "disinterested atten-
tion" means attending without those motives. The claim
that there is a perceptual or attentional power, the opera-
tion of which determines the aesthetic nature of experi-
ence, seems to be only the obvious observation that
people attend with different motives. Let us return to
Arthur and Marvin listening to the music. The motives
of the two men differ: Marvin has an ulterior purpose
and Arthur does not, but this difference does not require
Marvin's listening or attention to be different from
Arthur's. Possibly both men appreciate (in any or all of
the senses of the term) the music or do not. The atten-
tion of either or both may flag, either or both may be
bored, and so on. But there is only one way to attend to
(listen to) music, although the listening may be more or
less attentive and there may be a variety of motives and
reasons for doing so.

Although I believe the flaws in the aesthetic-attention
theory are completely revealed by the two cases just
examined, in order to avoid the appearance of a kind of
mistake all too common in aesthetics—drawing a conclu-

sion for all the arts after considering only one or two of them—I shall discuss cases of alleged interested and disinterested attention to other arts. But first let us return to the portrait of Zachary's father. Marvin now appears on the scene. Marvin, like Zachary, recognizes that the painting is a portrait of Zachary's father, thereby being aware that the painting stands in a certain relation to something beyond itself. Marvin, however, unlike Zachary, is not distracted from the painting by that recognition. I do not wish to suggest that Marvin's attention is somehow divided between the painting and what it represents because he recognizes it as representing a specific thing, for it is quite possible to concentrate fully on a painting while being at the same time aware that it represents some specific thing. Marvin, then, despite his knowledge of the relation of the painting to Zachary's father, is just as free as Arthur to appreciate the color harmony, spatial organization, and so on. The fact that a certain bit of knowledge about a painting *may* distract attention from it, as in Zachary's case, does not prove that that certain bit of knowledge *must* distract attention. Marvin perhaps runs more of a chance of being distracted than does Arthur, but when they attend to the painting, the attention of each is the same. Saying that their attentions are the same is somewhat misleading because it suggests that on some occasions their attentions might be different. I put it this way, however, because the aesthetic-attention theorists say that there are different kinds of attention. In any event, Arthur's attention does not differ from Marvin's.

Let us now consider a hypothetical example in which perhaps the strongest possible case can be made for interested perception. The three characters are sitting in a packed theater watching a preview performance of a play written by Marvin who is considering the possibility of rewriting the script. Zachary is the impresario of the production and Arthur, as usual, is the ideal spectator. Zachary is wholly absorbed with his thoughts of the full house and the future economic benefits it promises; he is completely distracted from the play and, therefore, not attending to it interestedly. The crucial character here is, of course, Marvin who attends closely to the play with an ulterior motive which involves the play intimately. It is possible that Marvin might not be able to appreciate the play, but I assume that if he does not appreciate it, it is not because his attention to it is different in kind from Arthur's. If Marvin does not appreciate the play, it might be because he is so busy taking notes or focusing intently on one or two characters whose parts he fears are in need of reworking. Marvin might be just too busy to appreciate the play. If he were distracted in this way, he would be distracted from the play as a totality, although not in the complete fashion that Zachary is. But if Marvin might not appreciate the play for some reason, it is not *necessary* that he would not under happier circumstances. It could happen that Marvin finds everything in the performance to his satisfaction, so that his ulterior motives do not require any note-taking behavior, attentive focusing on narrow aspects of the play, or other activities or

thoughts to distract him from the play as a totality. Quite possibly Marvin might be able to appreciate the performance with his ulterior motives in operation, noticing here something that needs changing, there that something would be better omitted, and so on. In this case, Marvin's position is similar to what it was when he listened to music in order to write about it on an examination, except that he now has the right to alter the work.

Let us now consider alleged cases of interested attention in the reading of literature, using examples cited by Vivas whose work has been so largely concerned with literature. Vivas asserts that "by approaching a poem in a nonaesthetic mode it may function as history, as social criticism, as diagnostic evidence of the author's neuroses, and in an indefinite number of other ways."[6] These nonaesthetic ways are presumably ways of transitively attending to poems, as is also the case he mentions later of a person who uses a poem or parts of a poem as a springboard for "loose, uncontrolled, relaxed day-dreaming, wool-gathering rambles, free from the contextual control"[7] of the poem. Before commenting on Vivas' cases of alleged transitive attention, let me note a conclusion he draws which is so odd that it serves as a clue and a warning that something is wrong with his theory. Vivas says that his definition of aesthetic experience "forces us to acknowledge that *The Brothers Karamazov* can hardly be read as art."[8] He is using the word "art" here to indicate that the novel in question cannot function as an aes-

[6] *Ibid.*, pp. 224–225. [7] *Ibid.*, p. 231. [8] *Ibid.*, p. 237.

thetic object. Vivas does not give any specific reasons for his conclusion. Perhaps its size and complexity are thought to prevent intransitive apprehension or perhaps because one can hardly read the novel except as social criticism. But it is hard to see how any reason could justify Vivas' conclusion. As a (great) novel, *The Brothers Karamazov* is a paradigm of an aesthetic object, and this fact ought to be taken as a datum for an aesthetic theory, not something which can be denied by a theory.

Imagine now our three characters reading a poem. Zachary first uses the poem as a springboard for "loose, uncontrolled, relaxed day-dreaming" and then turns to using the poem to diagnose the poet's neuroses. Neither of these activities can count as a special way of attending to the poem. Rather both are ways of being distracted from the poem. The distraction in either case might be momentary and insignificant or wholly absorbing, as in, say, speculations about the state of the poet's mental health. Even Zachary with his interest in the poet's neuroses might be able to attend to the poem, that is, he might, while searching for any information in the poem that seems to reveal something about the poet's mental state, attend to the poem and its content. Marvin, of course, would have no difficulty at all concentrating on the poem and looking for signs of the poet's neuroses, if he were ever to develop an interest in such extraliterary matters.

The other two ways that Vivas mentions as ways of attending to poetry transitively are reading it as history or as social criticism. These cases are different from those

just discussed in that poetry often contains history (historical references and statements) and social criticism but does not, for example, (usually) contain statements about a poet's neuroses. Consider the following three sets of poetic lines:

> In fourteen hundred ninety-two
> Columbus sailed the ocean blue.

> Or like stout Cortez when with eagle eyes
> He star'd at the Pacific—and all his men
> Look'd at each other with a wild surmise—
> Silent, upon a peak in Darien.

> That time of year thou mayst in me behold
> When yellow leaves, or none, or few, do hang
> Upon those boughs which shake against the cold,
> Bare ruin'd choirs, where late the sweet birds sang.

The first two of these sets of lines contain historical statements. Assume that Marvin recognizes these references and even notes the false historical statement. How is Marvin's attention different when he reads the first two from his attention when he reads the last set of lines? Or how is Marvin's attention different from the attention of Arthur who does not know of the historical facts referred to. There is no difference in kind of attention. As earlier, Marvin could be distracted in a way that Arthur cannot be, because he knows something that Arthur does not, but Marvin need not get distracted. The aesthetic-attention theory seems to yield the strange conclusion that Arthur's reading is better than Marvin's, because he does not (cannot) read the two sets of lines as history.

But it is obvious that Marvin's reading is better because it more fully grasps the content of the poem. Zachary, of course, upon recognizing the historical references, would immediately forget the poem and daydream about historical deeds, but then there would be no reading at all. Perhaps Vivas can be understood to mean by "reading as history," "reading *simply* as history"; but even so understood, a special kind of attention is not indicated. Reading *simply* as history would mean that only a single aspect of a poem is being noticed and that its rhyme, meter, and such features are ignored. Reading a poem as social criticism can be analyzed in a fashion similar to reading a poem as history. The aesthetic-attention theorists seem to want us to ignore the historical content and social criticism in literature, as if they were somehow not proper aspects of literature. Just how one can ignore such aspects by a switch in kind of attention is unclear. The suggestion that we ought to ignore historical content and social criticism is clearly mistaken; they are as much a part of literature (when they occur in it) as any other aspect of a work. How, for example, could Keats' poem be purified of its historical reference anyway?

The rationale that lies behind the whole aesthetic-attitude point of view seems to be the following. It had been thought from the time of Shaftesbury that disinterestedness played a central role in the experience of beauty or, as it came later to be stated, of aesthetic objects. The basic dictionary meaning of "disinterested," which is "not influenced by regard for personal advantage," applies literally, for example, to findings of boards of in-

quiry, verdicts of juries, and similar actions. When disinterestedness was coupled with the appreciation of beauty, the notion of disinterested contemplation somehow resulted, which literally would mean "contemplating something without any regard for personal advantage." But with the coming of "disinterested contemplation" to be a commonplace, first in the theory of taste and later in aesthetic theories, the expression seems to have come to mean "contemplating something without regard to *anything* in which it stands in relation." This new theoretical sense of "disinterested" showed up quite early and can be seen, for example, in Hutcheson's contention that:

This superior Power of Perception [the sense of beauty] is justly called a Sense, because of its Affinity to the other Senses in this, that the Pleasure does not arise from any Knowledge of Principles, Proportions, Causes, or of the Usefulness of the Object; but strikes us at first with the Idea of Beauty: nor does the most accurate Knowledge increase this Pleasure of Beauty, however it may super-add a distinct Pleasure from prospect of Advantage, or from the Increase of Knowledge.[9]

Hutcheson thinks that the alleged fact that the faculty of taste is a sense guarantees that it is disinterested in the new theoretical sense as well as the dictionary sense, that is, that the sense of beauty is triggered by a certain sort of object (uniformity in variety) independently of any relation in which such an object stands to any other thing. Hutcheson is saying that the sense of beauty is

[9] *An Inquiry into the Original of Our Ideas of Beauty and Virtue*, 2d ed. (London, 1726), p. 11.

triggered analogously to the way in which the eye sees, say, the redness of a red object: the eye sees the redness independently and even in spite of any relation—of personal advantage or otherwise—in which the red object stands to anything else. Thus the notion that the perceived object involved in the experience of beauty is experienced as not standing in relation to anything else became embedded very early in the theory that sought to explain the experience of beauty.

When theories of taste were supplanted by aesthetic theories, the notion of disinterestedness was retained but was now attributed to consciousness (perception, attention). Consequently, the aesthetic theories came to hold that there was disinterested consciousness (perception, attention), the exercise of which could put an object of consciousness (perception, attention) out of relation to anything else insofar as the exerciser was concerned. Experiencing something not in relation to anything else was seen as a necessary condition for that something being beautiful or a necessary condition for experiencing the beauty of that something. And as this was seen as a necessary condition, it was thought that if something is experienced in relation to something else, it is not beautiful or its beauty cannot be experienced. Apparently the notion of disinterestedness had come to seem so important to philosophers that it was carried over into the new kind of theory without question and without reflection on whether it fit into the new context. But whereas it perhaps makes some sense to speak of disinterested senses (automatic reactors to stimuli), it is not at all clear that it

makes sense to speak of disinterested consciousness (perception, attention) in the way required by the new aesthetic theories.

Please note that Shaftesbury, who apparently introduced the notion of disinterestedness (in the dictionary sense) into the theory that seeks to explain the experience of beauty, seeks only to show that the appreciation of beauty is different from the liking of something which gives or promises personal advantage. With the possible exception of a conflict of sexual desire with the appreciation of the beauty of the human body, Shaftesbury does not seem to think that interestedness is necessarily in conflict with the appreciation of beauty. Note also that Shaftesbury's Platonic conception of the sense of beauty is entirely different from that of Hutcheson and the other empiricist-minded philosophers.

The theory of aesthetic attention is, I have tried to show, confused. It is also instructive to go on to try to show how the theory has been used to support mistaken conclusions about the relation of criticism to the appreciation of art and about the effect that the moral content in a work of art has on appreciation.

Stolnitz and others claim that a critic's relationship to a work of art is *necessarily* different from that of others because he attends to it differently. Stolnitz, for example, declares that if a percipient of a work of art "has the purpose of passing judgment upon it, his attitude is not aesthetic."[10] He further claims that appreciation (which

[10] *Aesthetics and Philosophy of Art Criticism*, p. 35.

requires perceiving with aesthetic attention) and criticism (seeking for reasons to support an evaluation of a work) are: (1) distinct and (2) "psychologically opposed to each other."[11] According to Stolnitz, the critical attitude is questioning, analytical, probing for strengths and weaknesses, and so on. The aesthetic attitude is just the opposite: "It commits our allegiance to the object freely and unquestioningly; . . . the spectator 'surrenders' himself to the work of art."[12] "Whenever criticism obtrudes, it reduces aesthetic interest."[13] Stolnitz says that criticism plays an important role in preparing people to appreciate aspects of art. We should, he says, be able to read perceptively and acutely, but he questions, "Does this mean that we must analyze, measure in terms of value-criteria, etc., *during* the supposedly aesthetic experience?"[14] He answers in the negative, maintaining that criticism must occur "*prior* to the aesthetic encounter" or it will interfere with appreciation.[15]

Stolnitz's conclusion sounds like one based on observation of actual cases, but it is not. The conclusion is a logical consequence of his definition of aesthetic attitude in terms of disinterested attention. According to his view, to appreciate an object aesthetically one must attend to it disinterestedly (i.e., with no ulterior purpose). But a critic has an ulterior purpose, therefore, insofar as a person functions as a critic he cannot function as an appreciator.

[11] *Ibid.*, p. 377. [12] *Ibid.*, pp. 377–378. [13] *Ibid.*, p. 379.
[14] *Ibid.*, p. 380. [15] *Ibid.*

Here, as previously, Stolnitz and the other attention theorists confuse an attentional matter with a motivational one. If it were possible to attend interestedly or disinterestedly, then a critic would differ from a noncritic. But if my earlier argument is correct, a critic differs from noncritics only in his motives and not in the way in which he attends to a work of art.

Of course, even if critics and noncritics do not attend differently, the search for reasons, as Stolnitz characterizes criticism, might be incompatible with the appreciation of art, but, in fact, they are not incompatible. For example, I once participated in a series of panel discussions of films. During the showing of each film, I had to take note of various aspects of the film in order to discuss it later. The notation of things to serve as reasons not only helped educate me to appreciate subsequent films, it enhanced my appreciation of the film I was analyzing. I noticed and was able to appreciate things about the film I was watching which ordinarily out of laziness I would not have noticed. I see no reason why the same should not be the case for all critics. If many professional critics seems to appreciate so few works, the reason is not because they have to attend to them in a special way or with special motives, but because they are required to attend to so many works and the percentage of them worth appreciating is fairly small.

I am unable to see any significant difference between "perceptively and acutely" attending to a work of art, which Stolnitz correctly maintains enhances appreciation,

and searching for reasons. In order to attend perceptively and acutely, one must have standards or paradigms in mind (not necessarily consciously) and be keenly aware of the aspects of the work and evaluate them to some degree. Stolnitz writes as if criticism takes place and then is over and done with, but the search for and the finding of reasons (noticing that this fits in with that, and so on) goes on constantly in practiced appreciators. A person experienced in a particular art does not even have to be looking for a reason in the sense of being consciously aware that he is doing so; many of the things he notices about a work are simply seen as reasons why he thinks the work better or worse.

Stolnitz's remarks suggest that one reason he thinks criticism and appreciation incompatible is that they compete with one another for time. Such competition would be especially adverse in the case of performed works. But seeking and finding reasons does not take up time. First, to seek reasons means to be ready and able to notice something, and such seeking, unlike seeking for a needle in a haystack or for an honest man, does not take up any time. Not only does such seeking not interfere with appreciation, it may enhance appreciation because it tends to focus attention securely on the work. Second, finding a reason does not take time either—it is an achievement like winning a race or noticing the needle at a particular spot in the hay. It takes time to run a race and seek for a needle in a haystack, but not to win a race or notice a needle. Consider the finding of the following typical reasons: How much time does it take to notice that a note is

off-key (or on-key), that an actor mispronounces a word (or does it right), that a character's action does not fit his already-established personality, that a happy ending is out of place, that a colored area in a painting is perfectly placed, and so on? One is suddenly struck by such things. It just does not take time to find reasons. Finding a reason is like coming to understand—it is done in a flash. I am not somehow suggesting that one cannot be mistaken in finding a reason. What appears to be a fault or a merit in the middle of a performance or during one look at a painting may turn out to be just the opposite when seen from the perspective of the whole performance or more looks at the painting.

Aesthetic-attitude theorists are not the only ones, nor the first, to argue that criticism is incompatible with appreciation. Archibald Alison, for example, did so, arguing that as critics we "attend minutely to the language or composition of the . . . [poem] . . . , or to the coloring or design of the . . . [painting] . . . , [and] . . . we feel no longer the delight which they at first produce." "It is upon the vacant and unemployed [mind], sion."[16] At the present time, however, the attitude theorists are the ones who defend the thesis of the incompatists are the ones who defend the thesis of the incompatibility of criticism and appreciation and for this reason attention has been given to them.

The theory of aesthetic attention has also led to an

[16] *Essays on the Nature and Principles of Taste*, 5th ed. (Edinburgh, 1817), vol. 1, pp. 10–11.

unfortunate conception of the role of the moral content of art as it relates to the appreciation of art. Stolnitz, for example, writes:

Any of us might reject a novel because it seems to conflict with our moral beliefs. . . . When we do so . . . we have *not* read the book aesthetically, for we have interposed moral . . . responses of our own which are alien to it. This disrupts the aesthetic attitude. We cannot then say that the novel is *aesthetically* bad, for we have not permitted ourselves to consider it aesthetically. To maintain the aesthetic attitude, we must follow the lead of the object and respond in concert with it.[17]

An earlier aesthetic-attitude theorist, H. S. Langfeld, puts the matter even more flatly when he writes, "We are either concerned with the beauty of the object or with some other value of the same. Just as soon, for example, as ethical considerations occur to our mind, our attitude shifts."[18]

Stolnitz says that if we find fault with the moral point of view of a novel (and presumably with any work of art), it disrupts aesthetic attention. We must not, he says, "disagree" in any way with the object in order to maintain aesthetic attention. It is hard to see how one can *critically* appreciate anything while in the aesthetic attitude if one "must follow the lead of the object and respond in concert with it." It would seem that noting any defect in a work—moral, formal, or otherwise—is destructive of the aesthetic attitude. But Stolnitz, however, does

[17] *Aesthetics and Philosophy of Art Criticism*, p. 36.
[18] *The Aesthetic Attitude* (New York, 1920), p. 73.

seem to leave open the possibility that if the moral point of view of the work is not objectionable to a person, then the fact that the work has a recognizable moral point of view will not disrupt the aesthetic attitude. Langfeld, however, takes a stronger line, saying that moral considerations as such are inconsistent with the aesthetic attitude.

Langfeld's and Stolnitz's conclusions either entail or strongly encourage the belief that something is wrong with a work of art having a moral content; or, if that puts it too strongly, their conclusions encourage the belief that the moral point of view of a work can be isolated from its aesthetic aspects by training aesthetic attention on the work. But if the earlier argument of this chapter is correct and the notion of aesthetic attention is fundamentally confused, then there seems to be no reason to think that the moral content of art should be treated any differently from any other aspect of art. Probably no one would have thought otherwise, if they had not been misled into thinking that a moral point of view in a work of art raises an interest incompatible with the proper disinterested attitude of mind. The fact is that many, although not all, works of art have a moral point of view, and frequently, although not always, the moral point of view is one of the most important aspects of the work. Critics often take the moral content of a work very seriously, and philosophers certainly ought seriously to take account of the practice of critics rather than to try to explain away such criticism as irrelevant moralizing. In short, how can the theory which seeks to explain

the phenomenon of the experience of art try to explain away what is obviously such an important aspect of some art and an important reason for experiencing that art.

Even if someone thought that the moral point of view of a work ought somehow to be separated out from other aspects in the experiencing of it, it is difficult to see how this separation could be brought about. (Of course, someone might never be aware of the moral content of a work, but that is not a separating out—one would first have to be aware of the moral point of view in order to separate it out.) How, for example, can the reader of *The Adventures of Huckleberry Finn* separate out the moral point of view contained in Huck Finn's agonizing about whether he ought to turn Jim, the runaway slave, in to the authorities or to allow his fellow-traveler on the raft to escape. The moral point of view cannot be separated from the character of Huck Finn nor from a central theme of the book. The moral point of view of this novel is one, perhaps the main, reason why it is a great work of art. If someone were to succeed in separating out the moral point of view from the experience of this novel, he would have succeeded in reducing the appreciation of *The Adventures of Huckleberry Finn* to the appreciation of *The Adventures of Tom Sawyer*.

6

Aesthetic Perception: Seeing As

The final aesthetic-attitude theory I shall consider is that of Virgil Aldrich. I choose to discuss this theory for several reasons: (1) it is the most recent version of the attitude theory; (2) it purports to be related to some of the central notions of Wittgenstein's philosophy; and (3) although it clearly belongs to the attitude tradition, it is more explicitly concerned with the notion of aesthetic object as the proper object of appreciation and criticism than the earlier attitude theories are.

The earlier attitude theorists concentrated their attention on the description of the aesthetic attitude without giving much thought to the role that aesthetic objects play as the proper objects of appreciation and criticism. Aldrich explicitly raises the question of which aspects of a work of art are "proper parts" of an aesthetic object and which aspects are not. But having raised the problem, he unfortunately seeks to answer it by recourse to still another version of the aesthetic attitude. He maintains that there is a specific kind of aesthetic perception

which, if exercised, will reveal which aspects of a work of art *or nature* are aesthetic (that is, are proper parts of an aesthetic object) and which are not. Aldrich makes his official intent clear at the beginning of his book when he writes, "Our problem, then, is to state the conditions to be satisfied by the sort of perceiving that is properly called aesthetic, the sort that reveals aesthetic characteristics of things."[1] In a later article when talking about experiencing art, he shows that he continues to follow the aesthetic-attitude line in saying:

When *the work of art* is looked at in a certain way, one becomes aware of the aspects that dawn in the aesthetic space of the composition. These are proper parts of the work of art as an aesthetic object, and blindness to these is the sort of aspect-blindness that disqualifies one both for aesthetic perception and the assessment of the merits of the work as an aesthetic object in that view of it.[2]

In the two passages just quoted Aldrich says that one becomes aware of or has revealed to one the aesthetic characteristics of art and nature. He puts it this way because he maintains that aesthetic characteristics are objectively there to be experienced—one just has to look in a certain way to see them. He accuses the earlier versions of the aesthetic-attitude theory of subjectivism, and takes as his task the development of an objective account of the notion of aesthetic object—an account that has as its core notion the individual power of aesthetic perception.

[1] *Philosophy of Art* (Englewood Cliffs, N.J., 1963), p. 8.
[2] "Back to Aesthetic Experience," *Journal of Aesthetics and Art Criticism*, Spring 1966, p. 368.

Aldrich says that his theory of aesthetic perception was *suggested* to him by the phenomenon that intrigued E. H. Gombrich and Wittgenstein—the changing aspects of ambiguous figures such as the famous duck-rabbit drawing. Aldrich considers Figure 1 under five titles:

Figure 1

"(1) square suspended in a frame, (2) lampshade seen from above, (3) lampshade seen from below, (4) looking into a tunnel, and (5) aerial view of a truncated pyramid."[3] The figure can be seen as a representation of each of these in turn, just as the duck-rabbit can be seen now as a duck and then as a rabbit. Aldrich says that what is seen (the representation) is conditioned by what one has in mind, but that what is seen "is not just a thought or even just a subjective image; it is an object of perception of some sort."[4] Having talked about ambiguous figures, Aldrich begins a discussion of his theory of two kinds of

[3] *Philosophy of Art*, p. 20.
[4] *Ibid.*

perception: the ordinary mode of perception and the aesthetic mode of perception. He very carefully states that the phenomenon of ambiguous figures only suggested his theory to him, thereby indicating that the phenomenon is not supposed to be *evidence* for his theory. Nevertheless, the discussion of ambiguous figures "prepares" the reader for the aesthetic theory and the phenomenon is clearly supposed to serve as a kind of model for his conception of perception.

Aldrich's account of perception, of which his aesthetic theory is a part, involves what he calls "the phenomenon of categorical aspection" and runs as follows. There are two kinds of perception: the ordinary kind of perception characteristic of scientific inquiry and most everyday activity, which Aldrich calls "observation," and another kind of perception characteristic of aesthetic experience, which he calls "prehension." There is a neutral kind of entity which he calls "material thing." According to Aldrich, when a material thing is observed, it is realized in physical space as a physical object, but when it is prehended, it is realized in aesthetic space as an aesthetic object. Figure 2 is Aldrich's diagram of his theory. "Holophrastic perception" is apparently supposed to be a third kind of "neutral" perception, somehow between observation and prehension. Aldrich, however, has very little to say about it. If a diagram of the perception of the aspects of an ambiguous figure such as the duck-rabbit design is made, as in Figure 3, a striking difference between it and the diagram in Figure 2 can be seen. The right-hand sides of both diagrams are similar, but the

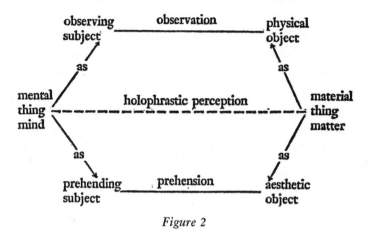

Figure 2

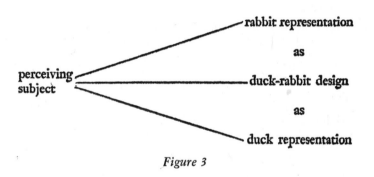

Figure 3

left-hand sides are very different. The phenomenon of
ambiguous figures in no way involves two kinds of per-
ception, although it involves two (or more) different ob-
jects of perception. The phenomenon, then, provides no
basis for the two kinds of perception suggested to Aldrich.
What the phenomenon of ambiguous figures suggests is
that there is only one kind of perception. Furthermore,

the duck representation and the rabbit representation, although different objects, are objects of the same type, unlike Aldrich's notions of physical object and aesthetic object.

But if ambiguous figures are not regarded as evidence for the theory of perception, why spend time worrying about whether there is a basis in them for what they suggested to Aldrich? The reason is that Aldrich does not give any arguments to work on, and his reader needs to have some idea of why he draws the conclusions he does. Using some impressive technical terminology, Aldrich simply states his theory of perception, saying that his theory gives an objective rather than a subjective account of aesthetic experience. But unless the reader is already convinced that the aesthetic-attitude approach is correct, that all earlier attitude theories are wrong because subjective, and that only one objective attitude theory can be formulated, then the reader will not be convinced by Aldrich's assertion of his theory. Just because, then, Aldrich does not give any argument to support his theory, it is important to show that there is not even any basis for this theory in his "inspiration."

Aldrich does give one alleged illustration of prehending in his book and another in a later article, and these can, I suppose, be considered arguments of a sort for this theory. In any event, a careful reader ought to take a close look at them. The first illustration is the following:

Take for example a dark city and a pale western sky at dusk, meeting at the sky line. In the purely prehensive or aesthetic

view of this, the light sky area just above the jagged sky line protrudes toward the point of view. The sky is closer to the viewer than are the dark areas of buildings. This is the disposition of the material things in aesthetic space with respect to their medium alone. It is precisely the medium in this sense that is discounted both in the observational view of them and in the plain, nonspecial view. Thus prehension is, if you like, an "impressionistic" way of looking, but still a mode of perception, with the impressions objectively animating the material things—there to be prehended.[5]

The second illustration involves the watching of illuminated snowflakes falling at night. If one focuses one's eyes on the snowflakes, they are seen in the ordinary way. If one focuses one's eyes at a point in the dark behind the snowflakes, they appear comet-shaped, tails up. The snowflakes seen as comet-shaped is supposed to be a case of prehending or aesthetic perception which Aldrich again characterizes as an "impressionistic" mode of perception.[6]

The first illustration is, according to Aldrich, an instance of one of *two* kinds of prehension—the kind which "involves getting the aesthetic space-values of the thing as structured simply by color and sound."[7] There are two quite different kinds of difficulty with the first illustration. The first is that although it would seem to be all right to say that the protruding sky area has a kind of impressionistic character, the fact does not justify saying

[5] *Ibid.*, p. 22.
[6] "Back to Aesthetic Experience," pp. 368–369.
[7] *Philosophy of Art*, p. 22.

that a special mode of perception has been isolated. Things taking on an unusual and pleasing appearance because of unusual lighting conditions is hardly reason for thinking that there is a special aesthetic mode of perception of which this occurrence is an instance. The second difficulty with Aldrich's illustration is that while the perception of the protuding sky area might indeed be an instance of what everyone would regard as an aesthetic experience, quite possibly the skyline scene with the sky and buildings seen in their actual spatial relation might also be an instance of what everyone would regard as an aesthetic experience. There is no reason to think that apparent reversed spatial relations is a special mark of aesthetic experience. Equally, there is no reason to think that a specific mode of perception is responsible for the apparent spatial reversals.

Aldrich's second kind of prehension allegedly occurs when something is seen "as something that it is not thought really to be; the [ambiguous] figure is not mistaken for a lampshade while it is being seen as one, but it is animated by the image of something else. Representational works of art feature this second kind of animation. Both sorts of aspects or animation occur without any change in observable qualities of the thing as a physical object."[8] The case of "snowflakes seen as comet-shaped" is presumably also an instance of this second kind of prehension, because the snowflakes are seen as something they are not thought really to be. As with the skyline

[8] *Ibid.*

case, there are two quite different kinds of difficulty with the comet-shaped snowflakes case. First, although there seems nothing wrong with saying that the comet-shaped snowflakes have an impressionistic character, this fact does not justify saying that a special mode of perception has been isolated. Getting uncommon and pleasing results from focusing one's eyes in an unusual way is hardly reason for thinking that there is a special aesthetic mode of perception. The second difficulty is that while the perception of the comet-shaped snowflakes might well be an instance of what everyone would regard as an aesthetic experience, quite possibly the snowflakes seen as they ordinarily are seen might also be an instance of what everyone would regard as an aesthetic experience.

Aldrich mentions that representational art "features" the second type of prehension, presumably because the design of the work is seen "as something that it is not thought really to be." Aldrich's view of the experience of representation as prehension is difficult to evaluate because he simply asserts it without any explanation or development.[9] The seeing of a design as a representation, however, is quite different from the protruding skyline and the comet-shaped snowflakes, which he discusses at least a bit, although seeing a representation is the same sort of thing Aldrich was dealing with in his discussion of ambiguous figures. So Aldrich's discussion of ambiguous figures was something more than just a lead-in to his aesthetic theory. But be that as it may, the first difficulty of

[9] *Ibid.*, p. 24.

seeing a representation as a case of prehension involves Aldrich's contention that prehension is an impressionistic way of looking. Although perhaps it makes some sense to say that focusing one's eyes at a point behind what one is attending to is an impressionistic way of looking and perhaps a protruding skyline and comet-shaped snow-flakes have impressionistic characters, it is not at all clear how experiencing a representation as such is impression-istic in any way. Even looking at an impressionistic paint-ing does not involve an impressionistic way of looking. One might try looking at representational paintings by focusing one's eyes at a point behind the paintings or by squinting at them as is sometimes done to screen out de-tail and make the large-scale composition more obvious, or in some other similar way, and perhaps one could say that these are impressionistic ways of looking at repre-sentations. But the usual way of looking at paintings is not like these ways of looking, and it is the usual way that Aldrich must describe.

The second difficulty in seeing a representation as a case of prehension is actually the application of a con-clusion I drew about the perception of the aspects of ambiguous figures. Just as there does not seem to be a special mode of perception required to see the duck or rabbit representation as contrasted with seeing only the black and white line design, no special mode of percep-tion is required to see the representation in a painting. Training and experience no doubt are required in order to be able to see representations, but that is quite differ-ent from saying that a mode of perception or a way of

looking enables one to see representations. A third difficulty with Aldrich's view is that while a seen representation may be the focal point of what everyone would agree is an object of aesthetic experience, many seen representations are not regarded as objects of aesthetic experience. Who would regard the duck representation or lampshade seen from above as objects of aesthetic experience? But if designs are seen as representations in virtue of being prehended and the remainder of Aldrich's theory were true, then every seen representation would engender an aesthetic experience. Whatever scope the expression "aesthetic experience" has, it does not encompass every recognized representation.

Aldrich's conception of aesthetic object as the set of characteristics revealed by the exercise of aesthetic perception is in difficulty because there does not appear to be any justification for saying that there is a specific kind of aesthetic perception. Nevertheless, Aldrich's theory is something of an advance over the earlier theories in the aesthetic-attitude tradition, for despite the way in which he tries to solve the problem, he explicitly states that aesthetic objects are the proper objects of appreciation and criticism.

None of the three versions of the aesthetic-attitude theory, then, gives any reason to think that there is an individual power, the specific function of which is either to change nonaesthetic characteristics into aesthetic ones or to make aesthetic features accessible. The general question, left unanswered at the end of Chapter 3, of whether, for example, deployed pigments can be "trans-

formed"[10] into designs by the operation of the aesthetic attitude can now be answered. If an aesthetic attitude does not exist, there is no reason to think that such "transformations" occur. In the following chapter I shall attempt to develop a conception of aesthetic object that does not make use of any aesthetic-attitude notion.

[10] Aldrich's use of the term "transformed" suggests that he holds a strong version of the aesthetic-attitude theory, but the theory he actually presents is a weak version, because he maintains that aesthetic features are *objective* and that aesthetic perception just enables one to experience them.

7

Aesthetic Object: An Institutional Analysis

In Chapter 1 an institutional analysis of art was offered, the main thesis of which was that art is a conferred status. Now an institutional analysis of the notion of aesthetic object will be attempted, the main thesis of which will be that the aspects of a work of art which belong to the aesthetic object of that work of art are determined by the conventions governing the presentation of the work. In developing my own conception of aesthetic object I will be following the lead of Monroe Beardsley. In so doing, it will be necessary to reject one part of his theory and to develop a network of ideas underlying his theory but not explicitly recognized by him.

It is instructive to contrast the aesthetic-attitude theorists' conception of aesthetic object with Beardsley's. The attitude theorists define "aesthetic object" as "the object of the aesthetic attitude," which, depending upon the version selected, means that by definition an aesthetic object is conceived to be the object of psychical distancing, disinterested attention, or aesthetic perception. Given

this definition, an aesthetic object may or may not be an object of appreciation and/or criticism; if it is, that is just a contingent fact. I do not think attitude theorists have paid much attention to the nature of the relation between their conception of aesthetic object and the phenomena of appreciation and criticism. Perhaps it is because they have been so little concerned with the philosophy of criticism. They have been almost wholly absorbed in working out, with ideas inherited from an earlier period, an account of the phenomenology of the alleged aesthetic attitude and a description of the individual power that underlies and is responsible for the attitude. In short, they have not been concerned with the appreciation and criticism of the arts but with a philosophical theory which, as has been noted, does not work. Beardsley, by contrast, comes to aesthetics with criticism and appreciation as his major concerns. The full title of his book is *Aesthetics: Problems in the Philosophy of Criticism*[1] and he calls his view "metacriticism." For Beardsley the term "aesthetic object" means something like "the object of appreciation and/or criticism," which entails that the relation between aesthetic objects and appreciation and criticism is one of meaning, not a mere contingency. Thus, although the attitude theorists and Beardsley use the same expression, they mean quite different things by it. Beardsley is, I believe, the first philosopher to conceive of aesthetics as the philosophy of criticism *and* to attempt to work out in any detail a metacriticism theory of aesthetic object.

[1] (New York, 1958).

Moreover, his conception is free of any commitment to the notion of aesthetic attitude. His pioneering work is not, as I shall try to show, completely successful, but he has opened up a new direction for aesthetics and deserves great credit for having done so.

Beardsley begins the development of his conception of aesthetic object by talking about the criticism of a play. He first makes a list of what he calls "typical statements," which he says everyone would agree are about "the play itself."[2] By "the play itself" he clearly means "the aesthetic object of the play." The list includes statements such as "The first act is slow" and "The irony at the end of the second act is overstressed." He then says, "Suppose we set aside the doubtful cases for the moment; we still have plenty of typical ones. And let us introduce the term *"aesthetic object"* for whatever it is that those typical statements are about."[3] Beardsley then raises the question of what sorts of things do and do not belong to the aesthetic objects of works of art. His procedure makes clear that he is certain about some of the contents of aesthetic objects, namely, the referents of his "typical statements," but there are still the "doubtful cases" he mentions. His problem is to identify the doubtful cases, to discover whether the referents of the doubtful statements belong to an aesthetic object, and to justify the classification.

The development of Beardsley's theory of aesthetic

[2] *Ibid.*, p. 16.
[3] *Ibid.*

object takes place in two stages. I shall first sketch the stages in broad outline and then discuss them in detail. The first stage consists of developing and applying what I shall construe as two principles, whose primary function is to *exclude* certain aspects of works of art and certain other things from the aesthetic objects of works of art. The two principles may be called the "principle of distinctness" and the "principle of direct perceptibility." He uses the first principle against intentionalist criticism which, in his view, mistakenly takes the intention of the artist who produces the work of art to be an aspect of the aesthetic object of that work. The second principle is invoked to avoid confusing those perceptual aspects of works of art which belong to aesthetic objects with what he calls the "physical" aspects of works of art, which do not belong. Stage One concludes with the observation that while all aesthetic objects are perceptual objects, not all perceptual objects are aesthetic objects: "Aesthetic objects are perceptual objects, but so are other things, for example, cows, weeds, and bathroom fixtures."[4] Beardsley then asks, "What distinguishes aesthetic objects from other perceptual objects?"[5] The role of Stage Two is to make the distinction. In Stage Two, Beardsley proposes that the problem be attacked by considering various perceptual fields separately, with the result that a conception of aesthetic object for various perceptual modes and for some combined modes will be arrived at: for example, a visual aesthetic object (visual design), an

[4] *Ibid.*, p. 58.
[5] *Ibid.*, p. 59.

auditory aesthetic object (musical composition), and so on. Beardsley promises that "once we have considered the basic properties of the visual field, we can distinguish visual aesthetic objects from other visible objects,"[6] and the same procedure is to be applied to the other perceptual fields. When this procedure has been carried out, he thinks he will have arrived at a disjunctive conception: an aesthetic object is anything that is either a visual design, musical composition, literary work, and so on.

Before going on to a detailed discussion of Beardsley's theory, let me illustrate how it is supposed to work in the case of a concrete example. Consider a spectator at a play: there are a number of the play's aspects that he can see and hear and a number that he cannot, and, in addition, there are things related to the play that he can see or think about. For example, (1) he can see and hear the onstage performance, (2) he cannot see the backs of the set flats and the stagehands behind the sets, (3) he can see the back of the head of the spectator in front of him (the head is spatially related to the onstage performance), and (4) he can think about the author's intentions. Beardsley quite correctly thinks that these various things belong to different domains, and his theory of aesthetic object is supposed to show that they do. The principle of distinctness is supposed to show that the author's intentions, although related, are distinct from the onstage and backstage performances. The principle of direct perceptibility is supposed to show that the nonperceptible

[6] *Ibid.*, p. 64.

backstage performance of the stagehands is not an aspect of the aesthetic object of the play and that the perceptible onstage performance of the actors is. And finally, the examination of the basic properties of perceptual fields is supposed to show that the perceptible spectator's head is not an aspect of the aesthetic object of the play.

Beardsley's arguments against intentionalist criticism are so well known that it is not necessary to devote space to their exposition.[7] Briefly, he argues that although a work of art and its maker's intentions are related, they are distinct things and to treat the intentions as an aspect of the work of art (or of the object of criticism and/or appreciation of the work) ignores this distinction. In contrast with the procedure of the attitude theorists, Beardsley's argument does not rely on the exercising of any individual aesthetic power but purports to be based upon the noticing of a distinction. Although he does not explicitly put it this way, the basis of Beardsley's argument may be formulated as the principle of distinctness: in order for something to be an aspect of an aesthetic object of a work of art, it must be an aspect of a work of art. As we have seen in the case of the spectator at the play, the principle of distinctness serves to *exclude* some things (intentions), which are not aspects of works of art, from

[7] See W. K. Wimsatt and Monroe Beardsley, "The Intentional Fallacy," *Sewanee Review*, 1946, pp. 468–488, reprinted in numerous anthologies; Beardsley, *Aesthetics*, pp. 17–29 and 457–460; Beardsley, "Textual Meaning and Authorial Meaning," *Genre*, July 1968, pp. 169–181. See also George Dickie, *Aesthetics: An Introduction* (Indianapolis, 1971), pp. 110–121 and Dickie, "Meaning and Intention," *Genre*, July 1968, pp. 182–189.

the aesthetic objects of works of art. The problem of *ex-cluding* the back of the head of the spectator in the row ahead and the backstage performance of the stagehands from the aesthetic object of the play and of *including* the onstage performance remains.

Let us now consider the exclusion of the backstage performance and comparable aspects of art. At this point in his argument, Beardsley uses a list of statements about a painting; the following four from his list, plus a fifth I am adding are sufficient to show his argument:

1. It is an oil painting.
2. It contains some lovely flesh tones.
3. It was painted in 1892.
4. It is full of flowing movement.
5. Its back is painted black.

The fifth statement, which is similar to the backstage performance of the stagehands, provides continuity with the previous discussion of a spectator at a play because it refers to something ordinarily not seen. At first, he says, it may appear that the "it" in each sentence refers to the same object. But a fundamental distinction must be made in connection with the statements, and Beardsley tries to bring this out by asking, "How do we verify the truth of each statement?" For 2 and 4, "we can *see* that they are true: we can look at the painting and observe the flesh-tones and the flowing movement."[8] The method of verification is "direct perception of the painting it-

[8] *Aesthetics*, p. 30.

self."[9] For statement 1, a chemical analysis would be necessary to determine its truth or falsity, and for 3, it would be necessary to do historical research. Beardsley concludes that 2 and 4 refer to the aesthetic object of the painting and that 1 and 3 refer to what he calls "the physical basis" of the painting. What Beardsley calls "direct" perceptibility is held by him to be a necessary condition of being an aspect of an aesthetic object. This requirement may be formulated as the principle of direct perceptibility: in order for something to be an aspect of an aesthetic object, it must be directly perceptible. The excluding role of the principle is best shown when expressed in its equivalent contrapositive form: if something is not directly perceptible, then it is not an aspect of an aesthetic object.

Beardsley illustrates the perceptual/physical distinction further by showing how it works out in the cases of music, poetry, and movies. In the case of musical compositions the directly perceptible sound belongs to their aesthetic objects and physical sound waves do not. In the case of poems the directly perceptible sounds of the words belong to their aesthetic objects and the physical sound waves which cause the perceptible sound, the electrical processes in the brain which make possible the understanding of meanings, and the ink marks with which the poetry is printed do not. "The presented picture, as it appears" belongs to the aesthetic object of a movie and "the set used in making it" does not.[10]

[9] *Ibid.*
[10] *Ibid.*, p. 32.

Some of the items Beardsley mentions as not included in aesthetic objects, sound waves and electrical processes in the brain, are not the kinds of things that can be perceived at all, so the principle does not even have to be qualified by *directness* in order to rule them out. Being an oil painting is also not, I suppose, something that can be perceived either. Thus items like these three are easily excluded by the principle of direct perceptibility. The black back of the painting, the painting's having been painted in 1892, and the unphotographed edges and back of the movie set are different from the first items because they *are* perceptible. (The painting's being painted in 1892 was at least perceptible at one time in the past.) It can, however, be maintained that such items are not *directly* perceptible. The back of the painting, for example, is not perceptible under the normal conditions for experiencing paintings. The painting's being painted in 1892 is likewise not perceptible under normal conditions and neither are the edges and back of a movie set. Interpreting Beardsley's notion of directness in this way, "directly perceptible" means "perceptible under the normal conditions of experiencing the art in question." Although he is not explicit about it, Beardsley uses the perceptual/physical distinction to exclude from aesthetic objects two quite different kinds of things: things that cannot be perceived at all and things that are not perceived under normal conditions. This procedure has the somewhat confusing result of including quite different sorts of things under the title "physical," but this difficulty is perhaps terminological only.

The principle of direct perceptibility will not, however, exclude everything that Beardsley desires to exclude from aesthetic objects here in the second stage of the development of his theory. For example, the ink marks of the printed poem are perceptible as one reads it, that is, under normal conditions of experiencing a poem. (I am not, of course, claiming that reading a poem is the only normal way of experiencing poetry.) Similarly, the property man in traditional Chinese theater, mentioned in Chapter 3, is also *directly* perceptible. The perceptibility of these items is, however, not a problem for Beardsley *at this point* in the development of his theory, because it may be possible to exclude them in Stage Two, the role of which is to distinguish aesthetic aspects of works of art from the other perceptual aspects of works of art and from other perceptual objects. (I am here using the expression "aesthetic aspects of a work of art" to mean "aspects of a work of art which belong to the aesthetic object of the work" which in turn is equivalent in meaning to "the aspects of a work of art which belong to the object of criticism and/or appreciation." Later when I develop my own account of aesthetic object, I shall also understand "aesthetic aspects" and "aesthetic object" to have these same meanings, even though my account of aesthetic object is somewhat different from Beardsley's.)

If, however, the perceptible nonaesthetic aspects of art raise no problem at this point, the nonperceptible aesthetic aspects do. For example, the meaning of the poetic line "That time of year thou mayst in me behold" is not

perceptible but it is certainly an important aspect of the aesthetic object of the poem. And, of course, the same is true of any poetic line. One understands or fails to understand the meaning of a poetic statement; one does not perceive or fail to perceive the meaning in the same sense of "perceive" that one perceives the design and colors of a painting or the tones of a piece of music. A line may call up a mental image or a memory image and perhaps in some extended sense of the term the image is perceived, but even so, the image is not the meaning of the line.[11] The identification of the aesthetic aspects of works of art with their perceptual aspects (or some of their perceptual aspects) seems to work out rather well in the case of music, as Beardsley notes.[12] He says, "The question becomes sharper, and easier to answer, when we direct it to music. For it seems very clear that it is one thing to talk music, another to talk acoustics."[13] The fact that the theory seems to work for music, however, does not mean that it is satisfactory for all arts. Beardsley comes close to noting the difficulty in his theory as it applies to literature, for he says, "When we turn to those objects that involve words, it becomes much harder, as we shall see, to say exactly what the aesthetic object *is*, but it is no less obvious that it is *not* something physi-

[11] Joseph Margolis noted the difficulty about meaning and perceptibility in his review of Beardsley's book in *Journal of Aesthetics and Art Criticism*, December 1959, p. 266.

[12] I have recently heard of an as-yet unpublished paper by Bruce Morton in which he argues that there is a difficulty in saying that all aspects of music are perceptible.

[13] *Aesthetics*, p. 30.

cal."[14] Having almost noted the difficulty, he unfortunately turns his attention wholly to the discussion of the physical items which do not belong to aesthetic objects, thereby missing the opportunity to notice that the perceptibility requirement would exclude from the aesthetic object of literary works something as important as the meanings of words and sentences. Because at this point in his argument Beardsley is wholly concerned with the exclusion of "physical" aspects from aesthetic objects, he fails to note that his principle excludes too much. Later in his book, when he discusses literary works in detail, he treats meanings of words and sentences as aesthetic aspects. In doing so he shows that he is unaware of all of the consequences of his earlier use of the principle of direct perceptibility.

The failure of the principle is not restricted to the meanings of words and sentences; it fails to classify properly some of the aspects of some plays. In order to show this failure it will be necessary to distinguish the various types of things that are included within the object of appreciation and/or criticism of plays. First, there is the "play" itself and a typical critical statement about a play is "*Hamlet* is a tragedy." Second, there is the "production" of the play and a typical critical statement about a production is "Olivier's *Hamlet* emphasizes the sexual aspects of the play." Third, there are the "performances" in the play and a typical critical statement about a performance is "Olivier was magnificent as

[14] *Ibid.*, p. 32.

Hamlet."[15] Having made this three-fold distinction, I wish to focus attention on performances and performance statements. A critic might say, "Olivier's performance last night as Hamlet was magnificent. He delivered his lines with great power and he moved with great skill and grace." How would the critic justify his remarks to someone questioning them? By referring to what can be seen from a theater seat: certain things seen in the same performance of the play or in another performance of the same production (assuming that the performances would be very similar). This particular case raises no problem for Beardsley because everything relevant to the truth or falsity of the critic's statements is perceptible under the normal conditions of experiencing the play. Consider, however, Mary Martin's performance in *Peter Pan*. Suppose a critic said, "Miss Martin gave a perfect portrayal of boyish enthusiasm and displayed a super-human skill and grace by actually flying about the stage at various times." This critic's remark contains one true statement (let us suppose) and one statement that is clearly false. The truth of the first statement can be verified from a theater seat, but the falsity of the second cannot be determined from a theater seat because the wire that "flies" Miss Martin around the stage is imperceptible. The point here is that the totality of Miss Martin's performance cannot be understood and assessed simply on the basis of what is perceptible from a theater seat. Our

[15] For a discussion of production and performance, see *ibid.*, pp. 56–58.

naive critic in mistakenly crediting Miss Martin with the power of flight shows that in order to understand the performance correctly one must know that she is not moving through the air under her own power. If the critic is ignorant of the means of movement through the air and attributes it to the actress' powers, he attributes something to her performance which is not part of *her* performance. One must know of the existence of the imperceptible wire in order to understand and assess Miss Martin's "performance" of moving through the air, just as one must be able to see Miss Martin's perceptible facial and bodily movements in order to understand and assess her performance in portraying boyish enthusiasm. Consequently, just as her perceptible facial and bodily movements are an aspect of the object of appreciation and/or criticism, the imperceptible wire is also an aspect of the aesthetic object of the performance.

Consider another, and this time hypothetical, use of imperceptible wires. Suppose that at a ballet performance a dancer executes incredible leaps, leaps which are longer and higher than any ever done before. The dancer is skillfully using imperceptible wires.[16] Here we have something which is imperceptible but which is certainly

[16] The example of a dancer on imperceptible wires to illustrate the point I am making here was suggested to me by Ruth Marcus. Joseph Margolis in his review of Beardsley's book gives an example which makes this point well. He writes, "To know that the high-jumping male dancers of the Moiseyev ballet company are catapulted over the heads of the corps is certainly a part of a critical understanding of the company's performance" (p. 267).

an aspect of the object of appreciation and/or criticism. The dancer's performance cannot be understood and evaluated without reference to the wires and the part they play in his performance. A leap that would be regarded as magnificent without the use of wires might be rather poor if wires were used. Suppose a dancer with and a dancer without wires execute leaps of equal gracefulness and height. Let us suppose that the gracefulness of the leaps is unrelated to and the height of the leaps is related to the use of the wires. A critic who says that the performances are equally good with respect to gracefulness would be correct; a critic who says that the performances are equally good with respect to height, however would not be correct because one of the performances is aided and the other is not. Some may wish to attempt to distinguish the performance of dancers, which in the present case involves the imperceptible wires, as well as the skill of the dancers from the presentation of the dance, which is simply that which can be seen from a theater seat. They might then wish to maintain that only the presentation is part of the aesthetic object of dances. I grant that the distinction can be made but it does not follow from the fact that the distinction can be made that only one of the two things distinguished is properly appreciated and/or criticized. The presentation can be distinguished from the ballet of which it is a presentation, and the particular production of that ballet can be distinguished from both, but all three are fair game for appreciation and criticism. Critics regularly remark on and evaluate dancers' skill in performance and there is no

reason to think that when they do so they are confused.

The exhibited skills of actors and dancers are aspects of the aesthetic objects of produced plays and ballets. What of the unexhibited skills of painters? Although sidewalk artists are an exception, the skill of graphic artists typically is not exhibited. A painter's activity is removed from the scene of the presentation and appreciation of the work. A painter's skill must be inferred from looking at his work plus other information. Knowledge of a painter's skill, however, is not entirely different from knowledge of a dancer's skill, for when we infer that a dancer is or is not using imperceptible wires we do so on the basis of information not received simply from seeing the performance from a theater seat. Beardsley claims that "It is an oil painting" and "It was painted in 1892" are not about the aesthetic object of a certain painting, whereas "It is full of flowing movement" is. But perhaps we must know the medium in which a painting is done and the date it was painted in order to appreciate it properly. Maybe we must know whether a painting is an oil just as we must know whether a ballet dancer is using wires. Perhaps it is very difficult to obtain a quality a painting has with oil, but quite easy with another medium. We do admire a painter's skill with a particular medium, but Beardsley claims that this is admiration of the artist and not of his painting. Can, however, the wielder of a skill be so easily divorced from its product? Isn't the skill embodied in the product?

However the question of the painter's skill is decided, the cases discussed earlier have already shown that the

principle of direct perceptibility excludes too much. My conclusion concerning the principle may be put in the following way: while it would perhaps be impossible to have an aesthetic object with no directly perceptible aspects,[17] aesthetic objects with some aspects that are not directly perceptible do seem to exist. Beardsley's own definition of "perceptual object" would allow perceptual objects to have imperceptible aspects,[18] although he will not allow aesthetic objects, which are one kind of perceptual object, to have imperceptible aspects. Beardsley gives the following definition: "A perceptual object is an object some of whose qualities, at least, are open to direct sensory awareness."[19] The definition leaves open the possibility that some perceptual objects, and therefore some aesthetic objects, have imperceptible aspects. Beardsley, however, does not exploit this possibility. Regardless of how "perceptual object" is defined, some aesthetic objects clearly have imperceptible aspects. One might attempt to patch up Beardsley's theory by altering the principle of direct perceptibility in some way. There is, however, a difficulty in the second stage of his argument which should be dealt with before any reconstruction is attempted.

Stage One concludes, as noted earlier, with the remark,

[17] A poem "recited" to oneself silently might seem to be an exception, but such a poem has potential perceptual aspects in that it could be recited aloud.

[18] Margolis notes this in both his review, p. 266, and in his reply to Beardsley's rejoinder, *Journal of Aesthetics and Art Criticism*, June 1960, p. 527.

[19] *Aesthetics*, p. 31.

"Aesthetic objects are perceptual objects, but so are other things, for example, cows, weeds, and bathroom fixtures."[20] The task of Stage Two is to distinguish the perceptual objects that are aesthetic objects from those that are not. Beardsley claims that the distinction can be made as a result of the consideration of the basic properties of the various perceptual fields with the resulting disjunctive conception of aesthetic object: an aesthetic object is anything that is either a visual design, musical composition, or literary work. I shall discuss only Beardsley's treatment of visual design because it exhibits the kind of difficulty involved in each of the other disjuncts.

In the section devoted to the consideration of the basic properties of the visual field, which he entitles "The Analysis of a Visual Design,"[21] Beardsley gives a definition of "visual design" and says many important and interesting things about the qualities of color and the characteristics of line, figure, and mass. He does not, however, say anything that helps to distinguish aesthetic objects from other perceptual objects or anything that helps to distinguish the aesthetic aspects of works of art from their nonaesthetic, perceptual aspects. The part of this section in which one would expect the relevant distinction between the aesthetic and the nonaesthetic to be discussed is the part in which "visual design" is defined and the definition defended. Consider what Beardsley says in this passage. He first defines "visual design" as a bounded visual area which contains some heterogeneity.

[20] *Ibid.*, p. 58.
[21] *Ibid.*, pp. 88–97.

The "boundedness" requirement means that a visual design is marked out from its background and ensures that not every visual field is a visual design. His example of something not bounded is the sight of several square feet of brick in the middle of a brick wall. The "heterogeneity requirement rules out a clear blue sky and the like. The definition is quite broad and allows random scrawls on a sheet of paper and cracked window panes to be visual designs, as well as paintings and other works of visual art.

The difficulty most easy to notice is that Beardsley's examples of nonaesthetic objects—cows, weeds, and bathroom fixtures—are bounded visual areas containing heterogeneity and must, therefore, be classified as aesthetic objects. The fact, however, that his definition captures such things as cows, weeds, and bathroom fixtures is not really a theoretical embarrassment for Beardsley. His theory does not require that an aesthetic object be a thing of aesthetic value, and the fact that the world contains many aesthetic objects of little or no value need not cause him any concern.

The real problem for Beardsley's theory is that the second stage is so inclusive that it does not provide a systematic way of distinguishing (1) between the aesthetic aspects of works of art and some of their nonaesthetic aspects and (2) between the aesthetic aspects of works of art and things perceptually related to those works. Consider first a case Beardsley mentions in which the second stage of his theory may make the appropriate distinction, but does so, if it does, as a result of a kind of happy acci-

dent. Earlier it was noted that the ink marks in which a poem is printed, which Beardsley holds not to be an aspect of the aesthetic object of that poem, are perceptible under normal conditions and are, hence, not ruled out by the principle of direct perceptibility. Beardsley can in this case perhaps argue that the visual design made by the ink marks on the page belong to a different perceptual domain from that of the poem because poems are not visual objects and that, consequently, the marks do not belong to the aesthetic object of the poem. (The question of whether the domain of the poem is a perceptual one is ignored here.) In this case, the disjunctive form of Beardsley's definition that separates the different perceptual modes may allow the appropriate distinction to be made.

There are other cases, however, which the second stage of the theory cannot handle at all. Consider the property man in traditional Chinese theater, who appears onstage among the actors while the play is going on. He arranges properties and scenery and does such things as hold a certain kind of flag in front of the face of a "dead body" as it walks off stage. The discussion of this case must be handled in a restricted way: since Beardsley's treatment of visual design has alone been discussed, the nonvisual aspects of plays will be ignored. The onstage movements and actions of the actors are clearly aspects of the aesthetic object of plays. The movements and actions of Chinese property men, while aspects of the performance of plays in a broad sense, clearly belong to another domain from the movements and actions of actors.

Earlier it was noted that the Chinese property man is not excluded from the aesthetic object of plays in the first stage of Beardsley's argument by the principle of direct perceptibility, because he is visible under the normal conditions of experiencing such plays. He is not excluded in the second stage by the analysis of visual design either, because he is visible among the actors and objects on the stage and is, therefore, just one more element in the visual design defined by the boundaries of the stage. The situation can be described in the following way: there is a visual design which consists at a given instant of the Chinese property man as one element together with all the elements of the aesthetic object of the play visible at that instant. The Chinese property man is an aspect of *an* aesthetic object because he is an aspect of a visual design, but he is not an aspect of the aesthetic object of the play. The notion of visual design is not powerful enough to complete the exclusion of alien visible elements from aesthetic objects.

In the event anyone thinks that the Chinese property man is an isolated as well as an exotic example, the same sort of analysis can be given for more mundane cases. When one sits in a theater seat watching a play there are many things in one's visual field besides the onstage performance—the stage curtains, the footlights, theater seats, the backs of spectators' heads. Any of these things can be an element of a visual design which also includes the elements of the aesthetic object of a play visible at some instant. For example, suppose there is an actor on each side of the stage at one point in a performance and one spec-

tator in the middle seat of the front row. The two actors and the back of the spectator's head could constitute a triangular visual design for another spectator seated behind the first row. Similar sorts of situations can be described for the viewing of paintings. For example, an element in a painting, say, a red area in its center and a fire extinguisher of the same shade of red hanging nearby might constitute a two-term, color-harmonious visual design. Parallel situations could also be described for aesthetic objects perceived by other perceptual modes.

The most that can be said for Beardsley's contention that "once we have considered the basic properties of the visual field, we can distinguish aesthetic objects from other visible objects"[22] is that his analysis enables us to exclude from the class of visible aesthetic objects such things as sections of brick wall which have no clear boundaries and clear blue skies which have no heterogeneity. But the definition of "visual design" and the discussion of the basic properties of the visual field—qualities of color and characteristics of line, figure, and mass—do not furnish us with any way of distinguishing which elements in a visual *field* belong to the aesthetic object of a particular visual work of art and which do not. Of course, everyone (or almost everyone) knows which elements in a particular visual field belong to the aesthetic object of, say, a particular painting and which do not, but they do not know which is which simply as a result of having examined the basic properties of visual fields.

[22] *Ibid.*, p. 64.

If the question of the aesthetic objects of works of art is set aside and only *natural* visual aesthetic objects are considered, then perhaps Beardsley's analysis would suffice. Where natural visual aesthetic objects are concerned, we can be content to appreciate whatever happens to "fall together" into a visual design—the sunset, the sunset and the light reflected in the water, the sunset and the light reflected in the water and the boats on the horizon, and so on. Works of visual art, by contrast, have an inner life of their own in a way that natural occurrences do not: they are not simply elements which happen to "fall together" in a visual field.

I shall now review in a general way Beardsley's method of developing his theory of aesthetic object, and in so doing try (1) to suggest perhaps why he went wrong at the points already discussed and (2) to show in addition that in a way his theory even goes wrong at the point of the principle of distinctness. The way in which the theory goes wrong at this latter point, however, gives the clue which shows how the metacriticism theory of aesthetic object can be reconstructed. Beardsley begins by asserting that there is general agreement that certain aspects of specific works of art—the slowness of the first act, the overstressed irony at the end of the second act, lovely flesh tones, flowing movement, for example—are aspects of aesthetic objects of works of art. There are, however, doubtful cases, and Beardsley attempts to make explicit the *general* grounds for deciding the doubtful cases.

The prominence and importance of the perceptible

properties of art perhaps led Beardsley to think that the
notion of direct perceptibility and an examination of the
properties of perceptual fields would enable one to settle
the doubtful cases. The rich or delicate colors of a paint-
ing, the melancholy sound of a piece of music, the rhyth-
mic pulse of poetic language, for example, are of the
utmost importance in our experience of art. I tried earlier
to show, however, that the perceptible characteristics are
not the only important features of art. Perhaps another
factor that led Beardsley to put such stress on the per-
ceptible was the tradition in aesthetics that identifies the
aesthetic with "sensuous surface." Finally, Beardsley's
generally empiricist and specifically phenomenalistic ap-
proach has, I suspect, led him, when early in his book he
sets up his basic categories, to give undue emphasis to the
perceptible. As I noted earlier, later in his book (when he
is not thinking about basic philosophical categories but
giving analyses of the actual elements of poetry), he
treats the (imperceptible) meaning of words and sen-
tences as aspects for criticism and appreciation.

One or more of the above three possible influences
may explain why Beardsley's theory goes wrong on the
issue of perceptibility, but the important consideration is
that it does go wrong. Of equal or greater significance is
the fact that his theory goes wrong on the issue of dis-
tinctness, or if "goes wrong" is too strong, that the theory
does not sufficiently elucidate the presuppositions of the
use of the principle of distinctness. Beardsley uses this
principle to show that the intentions of artists are distinct
from the aesthetic objects of the works they produce,

and I think he is right in drawing the conclusion he does. In order, however, in the case of the experience of a particular kind of art, for someone to see that an artist's intentions and an aesthetic object are distinct, that person must already have a clear idea of what the contents of the objects of criticism and appreciation are for works of art of that particular kind. If a person did not have such a clear idea or could not come to have it as the result of reflecting on the matter, he could not be sure that an artist's intentions are not an aspect of the aesthetic objects of the works in question. What I want to stress here is that making the distinction Beardsley is talking about is dependent upon prior experience and knowledge of particular kinds of works of art and the way in which they are ordinarily experienced. Thus the principle of distinctness is not a principle that can be wielded in connection with a particular work of art by someone ignorant of the art form within which that work has a place. Beardsley's distinguishing between intentions and aesthetic objects presupposes this background knowledge but he does not call attention to it. If he had explicitly noted the role of background knowledge in these cases, he would have also been in a position to see that direct perceptibility and the understanding of the properties of perceptual fields are not the primary considerations he thinks they are. Beardsley himself in the middle of his section on the perceptual and the physical makes a remark that shows that perceptibility is not a primary criterion of aesthetic objects. He says, "In a movie the scene depicted appears to stretch out on each side—we see it as part of a whole, though in

fact the room may be the middle of a sound stage, and come to a stop just outside the range of the camera. When we talk about these things, however, we *recognize* that we are talking about different things: (1) the presented picture, as it appears, and (2) the set used in making it."[23] We know in such cases that we are talking about distinct things because we, as he says, *recognize* on the basis of what we know about movies that they are distinct. It just happens to be the case that for typical movies the presented picture is perceptible and the edges and back of the set are not perceptible under the normal conditions of experiencing them, and this contingent fact perhaps influenced Beardsley to think that perceptibility under normal conditions is a criterion for aesthetic objects. Even in a darkened movie theater there are many things (spectators' heads, for example) perceptible under normal conditions which the viewer simply ignores because he knows about movies and knows that such things are not aspects of the aesthetic objects of movies. A knowledgeable movie-goer knows what to attend to and what to ignore for the same reason that a spectator at traditional Chinese theater knows to ignore the property man and attend to the actors—they both have learned the conventions that govern the presentation and appreciation of the art forms they are experiencing. Knowledge of the same kind of conventions is presupposed in the experience of the other arts also. Consider how such presuppositions are built into Beardsley's remark about the

[23] *Ibid.*, p. 32 (italics mine).

verification of statements about the aesthetic object of a painting: "We can *see* that they are true: we can look at the painting and observe the flesh-tones and the flowing movement."[24] Beardsley is concerned, when he makes this statement, with direct perceptibility as a criterion of aesthetic objects, but note that the statement contains the direction "look at the painting." Here "painting" is being used as a shorthand for "the aesthetic object of the painting," and this means that the verification does not reveal anything of a general nature about aesthetic objects but only something about the specific properties of a particular aesthetic object. In order to verify statements about aesthetic objects we must already know what in general to look for and at, what to listen for and to, and so on.

What exactly are the conventions that knowledgeable theater-goers, museum-goers, and so forth, know about and how do they come to know them? Are the conventions all of the same type? I shall now try to give an account of the conventions and practices involved in the presentation and appreciation of the aesthetic objects of works of art. I shall begin with a discussion of traditional theater which because of its complexity offers a great variety of distinct items for discussion and because of its formality offers many explicit cues. In a theater the seats are so arranged as to cause spectators to face toward the stage where the aesthetic objects of plays are performed. The stage itself is raised above floor level. The arrange-

[24] *Ibid.*, p. 30.

ment of seats and the raised stage are *spatial* practices which direct the spectator's attention toward the appropriate spatial area. Performances do not occur on the stage at all times; in fact, they occur relatively infrequently, so *temporal* cues are given to indicate that the aesthetic object of a play is about to begin (the house lights dimming and going out) and is beginning (the curtain going up). In addition, the spectators are given printed programs which in various ways are correlated with the onstage occurrences. The parts of the aesthetic object of the play are indicated on the program and ordered by numbering (first act, second act, etc.) and the beginnings and endings of parts are correlated with the raisings and lowerings of the curtain. All of these devices locate the aesthetic object for the spectator. None of them, however, is necessary for a knowledgeable theater-goer to locate the aesthetic object of a play. Aesthetic objects of plays can be presented without these traditional conventions, and if the audience understands the *primary* convention of presentation, then everything can come off all right. The distinction between the primary convention and the many secondary conventions of theater is an important one. The primary convention is the understanding shared by the actors and the audience that they are engaged in a certain kind of formal activity. This convention is what establishes and sustains theater. (It is this understanding that controls the behavior and attention of the members of an audience rather than a special kind of psychological state as maintained by the

various aesthetic-attitude theories.) Traditional western theater and traditional Chinese theater have the same primary convention of presentation and appreciation; they differ with regard to some of their secondary conventions, but not all. A number of our present-day theaters have dispensed with many of the traditional secondary conventions. A great deal of "experimentation" is going on in the theater at the moment, some of which comes close to upsetting the primary convention of presentation. In fact, some of this "experimentation" seems motivated by the desire to come as close as possible to upsetting the primary convention without actually doing so, and perhaps some is an attempt to destroy or alter the primary convention.

In addition to secondary conventions which point to the aesthetic objects of plays, traditional western theater has another kind of secondary convention. A great deal of what is involved in a traditional western play is *hidden* from the audience. The stagehands' actions, for example, take place behind the scenes. The concealing of nonaesthetic features is a secondary convention of traditional plays. These conventions, like those just discussed, also help locate the aesthetic objects of plays by concealing things which might interfere or be confused with aspects of aesthetic objects. Thus when spectators watch plays in traditional theater or critics talk about such plays they have seen, the secondary conventions of the presentations themselves give may cues as to what belongs to the aesthetic objects of plays and what does not. But just as

secondary conventions which point to the aspects of aesthetic objects of plays are not necessary for locating those aspects, the secondary convention of hiding the nonaesthetic features of plays is not necessary either. The Chinese property man, for example, is visible on stage but is "screened out" by the primary convention of theater presentation; that is, the knowledgeable theater-goer knows to ignore the property man's presence. Parenthetically, it is worth remembering that the concealment of an aspect of a play is *not sufficient* to exclude it from the aesthetic object of that play, as the discussion of the *Peter Pan* case and the case of the hypothetical dancers on wires have shown.

Literary works as ordinarily experienced, although not presented in a performance situation, are nevertheless presented, usually with the help of a number of secondary conventional devices. Not all the text, for example, which appears between the covers of novels and books of poems describes or creates the aesthetic objects of novels and poems. Editor's introductions, footnotes, and the like, although they may be illuminating, are not part of what Beardsley calls "the world of the work." The nonaesthetic text is set apart from the aesthetic text in various ways: an editor's introduction comes clearly labeled before the text of the novel and the pages of the introduction may even be numbered in a different way, footnotes are numbered and placed at the bottom of the page and are set off by lines or white space. The beginning of the aesthetic text is usually marked by a "Chapter I" designa-

tion and frequently its first page begins a new pagination. If a book contains only aesthetic text, then only the primary convention of presentation is involved when it is experienced.

The presentation of paintings, like that of plays and unlike that of literary works, is typically public, but involves no performance. The *display* of a painting is the public aspect of the primary convention of presentation. That paintings are displayed with their fronts visible and their backs against the wall is a secondary convention which helps locate the aesthetic object of the painting for a viewer. For example, it might have been our practice to display paintings with their fronts to the wall, say, as the result of some historical association of visual art with the sacred. If this were our practice, everyone would know that in order to appreciate a painting one would have to turn it around.

Earlier the question was raised of how knowledge of the conventions is gained. This knowledge is learned in a variety of ways. It is sometimes learned by teaching: a parent's directing a child's attention to the action on the stage, a teacher's pointings and directions for schoolchildren on a museum tour, and so on. Even a small child's being taught to see graphic designs as representations is an instance of learning a convention employed in visual art. The conventions are sometimes learned from the observation of knowledgeable persons, that is, by listening to what knowledgeable people say about art and watching how they behave and what they attend to when ex-

periencing art. Sometimes the conventions for one art form are figured out from what someone already knows about the conventions of a similar art form. Incidentally, even when one is *taught* a convention, it is not taught by someone's saying, "It is a convention of theater that" A person who learns a convention by teaching does so by "catching on" as the result of someone's directing his attention to an aspect of a work of art. In the typical case such a person would not even be aware that he has learned a convention. The conventions that structure the experience of art are learned in much the same way that a native language is learned; that is, it is picked up in an unself-conscious way. Such conventions are part of the apparatus with which we experience art and this makes it difficult to notice them. Their very obviousness makes them difficult to notice. Once they are noticed, however, the psychological machinery of the aesthetic-attitude theorists and the epistemological mechanisms of Beardsley and others can be seen not to be necessary to resolve the problem of the aesthetic object. One way of describing what I am doing in the second part of this book is to say that I am trying to free the concept of the aesthetic from the psychologistic and epistemological analyses which philosophers have been giving since the nineteenth century.

Perhaps enough has been said by now to indicate how the aesthetic objects of works of art are located and distinguished from other aspects of works and from other things. In general, the ability to make the locations and distinctions in a given case depends upon an understand-

ing of the type of art of which the given case is an instance. This means that the distinguishing of aesthetic objects is a piecemeal affair, since it depends upon experience and understanding of specific art forms. Each art form has a primary convention or practice for presenting works of that type, together with a variety of secondary conventions of greater and lesser importance. Beardsley's insight that the conception of aesthetic object is a disjunctive notion is correct, although the details of that analysis are different from those he envisaged. The disjuncts do not derive from knowledge of the basic properties of perceptual fields but from our knowledge of the nature of the various arts. Perhaps the most general thing that can be said about whether an aspect of a work of art is included in the aesthetic object of that work is this: if one must know of the aspect in order to understand what is presented through a primary convention, then that aspect of the work is also an aspect of the aesthetic object of the work.

In the Preface to this book I claimed that the theory of art developed in Chapter 1 and the theory of aesthetic object worked out in this chapter are parts of a single institutional theory. That they are two parts of a single whole is perhaps now clear, but I shall try in a summary to show how the two parts fit together. Recall the definition of work of art which I gave in Chapter 1: A work of art in the classificatory sense is (1) an artifact (2) a set of the aspects of which has had conferred upon it the status of candidate for appreciation by some person or persons acting on behalf of a certain social institution

(the artworld). This definition, which is a summary of
the institutional theory of art as it was explained in Chap-
ter 1, specifies that the candidate for appreciation is *a set
of the aspects* of a work of art. The definition and the
material of Chapter 1 leave undiscussed the problem of
which aspects of a work of art are to be appreciated and
how these are to be determined; that is, the traditional
problem of distinguishing between the aesthetic features
and the nonaesthetic features of works of art is left un-
broached. I found it necessary at the end of Chapter 1 to
leave undiscussed the institutional theory of aesthetic ob-
ject, because I had first to refute the traditional and well-
entrenched theories of aesthetic object. That task having
been accomplished, I was able in the later parts of this
chapter to sketch out the basic features of the institu-
tional theory of aesthetic object and thereby complete
the outline of the institutional theory of art.

The primary and secondary conventions discussed in
this chapter which locate and specify the aesthetic fea-
tures of works of art are conventions of the artworld
described in Chapter 1, and the description of these con-
ventions is simply a further description of the artworld.
Quite naturally, when the concern is with what makes
something a work of art, as it is in Chapter 1, the empha-
sis will be on the aspects of the artworld that make
creation possible—on acting on behalf of an institution, on
conferring of status, on being a candidate, and on appre-
ciation. When, on the other hand, the concern is with
the aesthetic and nonaesthetic features of works of art, as
it is in Chapter 7, the emphasis will be on those features

of the artworld that govern and direct the spectator's attention. The connectedness of the two aspects of the artworld is obvious: the aesthetic object is the aspect of the work for the sake of which the art is created.

8

Aesthetic Experience: Affective Unity?

The expression "aesthetic experience" is used with great frequency by aestheticians, sometimes without any clear meaning attached to it and almost always without a precise idea as to the nature of the referent of the expression. The aesthetic-attitude theorists, however, do have a clear understanding of what they mean by the expression. For them an aesthetic experience is the experience of an object toward which one is taking the aesthetic attitude. Consequently, the attitude theorists' description of the referent of "aesthetic experience" consists primarily of a description of the phenomenological elements and structures of the alleged aesthetic attitude in its engagement with its object. If, however, my earlier analyses of the aesthetic-attitude theories are correct, these theories are fundamentally mistaken. Therefore, a discussion of the attitude theorists' accounts of aesthetic experience is not necessary. Of the philosophers who do not rely on the notion of aesthetic attitude, Monroe Beardsley is the only one I know who has attempted to

develop a theory of aesthetic experience with care and precision. Consequently, in this chapter I shall devote myself primarily to a discussion of Beardsley's view and to an attempt to see what conclusions about aesthetic experience can be drawn as a result of reflection on the strengths and weaknesses of Beardsley's theory. Beardsley in developing his account draws primarily on the theories of John Dewey and I. A. Richards and tries to make precise and coherent some of their engaging but rather vague ideas. The stated aim of Beardsley's theory is to "distinguish an aesthetic experience from a non-aesthetic one in terms of its own internal properties."[1]

Beardsley's statement of his theory involves a rather elaborate account of the elements of aesthetic experience and their various relations. In order to help make his account clear it will be useful first to make a sketchy inventory of the elements of ordinary experience of which aesthetic experience is supposedly a species. In making this inventory I shall employ the terminology Beardsley uses, although I shall introduce one or two considerations of my own. Suppose I am having the experience which includes the perception of an ordinary kitchen chair. The phenomenally objective features of this experience are such perceptual aspects as the whiteness of the chair, the smooth feel of the chair's surface, the visual pattern made by the wooden slats of the back of the chair, and so on. This particular experience has, let us suppose, phenomenally subjective features—an emotion of rage and a split-

[1] "Aesthetic Experience Regained," *Journal of Aesthetics and Art Criticism*, Fall 1969, p. 5.

ting headache. The subjective features may or may not be significantly related to the objective features mentioned. If I had been seized by the emotion and gotten the headache as a result of seeing the chair, which figured in an earlier traumatic episode of my life, then the phenomenally objective and subjective features of the experience would be significantly related. The affects (the phenomenally subjective rage and headache) are the effects of the phenomenally objective chair. On the other hand, if the rage and headache had been induced by episodes unconnected to the chair or simply by physiological causes, then the perceived characteristics of the chair and the rage and headache would be related only in being events in the same consciousness at the same time. In this case the affects are not the effects of the phenomenally objective chair. Consider now a third experience involving the same kitchen chair. I am sitting in the kitchen early in the morning waiting for the coffee water to boil. Everyone else is asleep and the house is quiet. I am examining the surface of the chair and calmly and quietly considering whether to repaint it this year or put the repainting off until next year. In this particular experience, as it happens, there are numerous phenomenally objective features but few, if any, phenomenally subjective ones: no pains, no pleasures, no anxieties, no fatigue. The undecidedness about what to do is the only possible phenomenally subjective element here. In the three cases discussed I have spoken of the phenomenally objective and subjective features of experience, but have not explicitly called attention to the subject who is the center

of the experience. In the cases discussed the subject who has the experience is, I am supposing, normal, that is, not suffering from any mental defect and is, as we might say, psychologically integrated. A person suffering from a mental defect in situations similar to the three described would have quite different experiences. Suppose, for example, a person suffering from a severe memory defect were in the described situation; such a person might not be able to keep the various objective and subjective features "together." He might not realize that the chair he now sees is identical with the one he saw a moment ago, or even that he saw a chair a moment ago. His rage might cease because he forgets the cause of his anger (although he would remain agitated for a while because of the chemicals in his bloodstream). In short, such a person could not have normal, integrated experiences; compared with normal experiences, such experiences are incoherent.

I shall now state Beardsley's theory of aesthetic experience. He first set forth his theory in his book.[2] He then defended parts of the theory in a journal article[3] against criticism raised by me[4] in such a way as to alter slightly some aspects of the parts of the theory discussed in his article. The theory of aesthetic experience I shall now attribute to Beardsley is the view of his book as I understand it to have been slightly revised. The criticism of his

[2] *Aesthetics: Problems in the Philosophy of Criticism* (New York, 1958), pp. 527–530.

[3] "Aesthetic Experience Regained," pp. 3–11.

[4] "Beardsley's Phantom Aesthetic Experience," *Journal of Philosophy*, March 4, 1965, pp. 129–136.

view that I shall give here is rather different from the one I originally made. I shall not make any attempt to give an account of our dialogue, but shall proceed directly to a criticism of Beardsley's revised view.

At the beginning of this chapter I noted that there are two problems to be dealt with—the meaning of the expression "aesthetic experience" and the nature of the referent of that expression. Beardsley does not give a definition of "aesthetic experience," rather he gives directions for locating aesthetic experiences by means of his notion of aesthetic object. He cannot *define* "aesthetic experience" in terms of aesthetic object because later on in his book he will say that aesthetic experience may be derived from things other than aesthetic objects. Beardsley deals with both problems in the same sentence when he writes, "The problem is whether we can isolate, and describe in general terms, certain features of experience that are peculiarly characteristic of our intercourse with aesthetic objects."[5] And he does think that the general and peculiar characteristics of aesthetic experience, so located, can be isolated and described. I shall not, by the way, raise any questions about Beardsley's use of the notion of aesthetic object in locating aesthetic experience, because I am assuming that a clear account of the notion of aesthetic objects (of works of art) can be given, even if Beardsley's own account involves difficulties. The question I shall focus on is whether Beardsley is right in thinking that the experiences of the aesthetic objects of

[5] *Aesthetics*, p. 527.

works of art have certain features—the internal properties mentioned earlier which he thinks distinguish them from nonaesthetic experiences.

Beardsley characterizes aesthetic experience in his journal article as follows: "I propose to say that a person is having an aesthetic experience during a particular stretch of time if and only if the greater part of his mental activity during that time is united and made [intense, complex, and] pleasurable by being tied to the form and qualities of a sensuously presented or imaginatively intended object on which his primary attention is concentrated."[6] I have inserted the bracketed words because in the earlier account in his book he maintained that aesthetic experience is intense and complex as well as unified, and I assume he still wishes to do so. My original criticism had concerned only unity of experience, and for this reason I assume his reply focuses only on this presumed feature of aesthetic experience. In this chapter also I shall confine myself to a discussion of the alleged unity of aesthetic experience. It may be useful in understanding Beardsley's theory of aesthetic experience to know that in his view aesthetic experiences may vary in magnitude according to their greater or lesser degrees of unity, intensity, and complexity and that also the greater the magnitude of an aesthetic experience, the better the work of art which produced it is supposed to be. His account of aesthetic experience is the basis for his theory of critical evaluation.

[6] "Aesthetic Experience Regained," p. 5.

First, what exactly is it that Beardsley is claiming is unified? The elements of aesthetic experience are of the same type as those of ordinary experience. The phenomenally objective features of a painting are of the same kind as those of a kitchen chair—colors, shapes, and their relations. I agree with Beardsley that the phenomenally objective features of aesthetic experience possess unity, or at least I agree that the great majority are unified. Typically, works of art have features that are unity-making—harmonizing colors, contrasting colors, alliterative sounds, rhyming sounds, and the like. The phenomenally objective features of nonaesthetic experience also typically possess unity of some degree, otherwise the perception of them would be difficult (perhaps impossible). I would agree, however, that the phenomenally objective features of the typical aesthetic experience are more highly unified than those of the typical nonaesthetic experience. In this instance, we are talking about the unity *in* experience, that is, about the experience of perceived unity; but the aspect of Beardsley's theory I wish to question is the contention that aesthetic experience is unified, that is, that there is a special unity of experience.

Beardsley makes a number of claims about aesthetic experience. First, he holds, and I agree, that we experience (perceive) unity (coherence and completeness) in works of art. Second, he claims that the perceived unity causes affects—feelings and emotions, and expectations and satisfactions of expectations. Third, he claims that the affects are unified among themselves. Fourth, he

claims that the unified elements of a work of art and the unified affects caused by the work go together in such a way as to constitute a higher order unity, and this higher order unity is what he refers to as the unity of "experience as such."[7] In his view, as I understand it, the unity of experience as such is one of the internal properties that distinguishes aesthetic from nonaesthetic experience. (The other properties are intensity and complexity of experience which are not being discussed here.) Beardsley defends his claims by describing two hypothetical musical experiences—the first to illustrate one kind of unified experience (a coherent one) and the second to illustrate the other kind of unified experience (a complete one). Since his thesis is a positive one about all aesthetic experience, he must marshall considerably more evidence than these two examples, both of which are experiences of sequential works of art and from a single art form. Representative cases from the whole range of works of art are certainly required.

The first difficulty with Beardsley's view is that there are many cases regarded by everyone as aesthetic experiences but having no affective content caused by a work of art. Thus even if the cases he gives are correctly described, his theory is inadequate because it does not cover all relevant cases. I have in mind, for example, the experience of a certain kind of abstract painting which has a good but simple design and which can be taken in, as it were, at a glance. The fact that the design can be taken in at a glance does not mean that one need only

[7] *Ibid.*, p. 6.

glance at the painting. Such paintings frequently repay continued attention. The fact that the design is taken in at a glance means that the painting arouses no expectations, which are a kind of affect. It is doubtful, by the way, that paintings in general raise expectations, although perhaps a few do. The appreciation of such a painting does not evoke the kind of affect (uncertainty about future action) that was aroused in the experience of the kitchen chair either, because the question of future action does not ordinarily arise in the appreciation of such paintings. Abstract paintings frequently arouse feelings and emotions, but the kind I now have in mind does not; one finds it very pleasant to look at and to continue to look at such a painting, but no feelings or emotions are produced. Beardsley may be correct in saying that aesthetic experience is always pleasant, but the pleasure is not always (perhaps not even usually) an affect, i.e., a feeling. We are frequently pleased by something without having a feeling of pleasure. For example, a father may be pleased when he sees that his son has brought home, as he always has before, a good report card, but not actually experience a *feeling* of pleasure. On the other hand, if a son who has always brought home a bad report card suddenly brings home a good one, his father may be *so* pleased that a feeling of pleasure may be produced in him, just as patriotic music produces in some people feelings that run up and down the spine. Beardsley does not, by the way, say that pleasant feelings are among the kind of affects that constitute the elements unified in aesthetic experience, but he does claim that aesthetic ex-

perience is pleasurable. He might think, therefore, that aesthetic experience always involves affective pleasure, and I have taken the precaution to note that even if aesthetic experiences are always pleasurable, they do not always contain affective pleasure.[8] I am inclined to think that many of our aesthetic experiences are without affective content, not just a few ones of abstract paintings. We sometimes have emotional feelings as a result of looking at representational paintings, as for example when we look at Goya's depictions of executions. In the overwhelming majority of cases (and this includes most of the experiences of paintings we either like or think good), paintings do not produce emotional feelings or expectations. What has happened, I think, is that those instances that do produce feelings tend to stand out in memory and because they do, they have been taken as typical. It is easy to remember the great affective impact of Goya's etchings *The Disasters of War* or of Miller's *Death of a Salesman*, to mention two cases on the tragic side, and to think that if such cases have a great impact then every case must have some affective consequence. Such a line of reasoning would yield the conclusion that

[8] Henry Sedgwick noted the ambiguity in "pleasure" upon which my remarks hinge. I do not know, however, if he was the first to do so. The word "pleasure" and its cognates are sometimes used to indicate nonaffective pleasures—"I am pleased to see you," "It gives me great pleasure to introduce . . . ," "The pleasure is all mine," "We had a pleasant conversation"—and sometimes to refer to pleasant affects—"The ice cream has a pleasant taste," "The pressure applied to my sore back was very pleasant."

because a great pressure produces a great pain, a small pressure must produce a small pain. But a small pressure sometimes produces a small pleasure, and sometimes even a great pleasure. The moral here is that the complete range of aesthetic experiences has to be examined before a general conclusion can be drawn.

Many aesthetic experiences do not have affective content and this spoils the generality of Beardsley's theory. Many aesthetic experiences, however, do contain affects which are produced by works of art and perhaps Beardsley's theory fits them. Suppose I am watching a performance of *Hamlet*. When the ghost appears I might have a feeling of fear. I might feel angry when I hear the ghost say he was murdered, but then I might feel distrustful (is this an affect?) because it occurs to me that the ghost may be a projection of Hamlet's unconscious. As the play progresses, I might feel irritated by Polonius' fatuous speeches, pity for Ophelia's plight, indignation at the king's attempt to have Hamlet murdered, and so on until near the end I might feel excitement at the final confrontation and sword fight between Laertes and Hamlet. Finally at the end, I might feel pity and sadness at the death of Hamlet. During the course of the play I might have felt fear, anger, distrust, irritation, pity, indignation, excitement, pity, and sadness, not to mention the many other feelings the play might produce in a spectator. How does this sequence of affects constitute a unity? True, they are all elements in the single consciousness of a psychologically integrated person and have that kind of unity, as do the affective elements of all

experiences of normal persons, but in Beardsley's theory the affects are supposed to have properties that establish relations among themselves. Analogous to the way in which the sound properties of words enable certain words to rhyme and thereby unify these words and the lines in which they occur, Beardsley's theory is committed to maintaining that the feelings evoked by *Hamlet* have properties which unify those feelings, since *Hamlet* is a good play. Concerning the properties of feelings Beardsley says the following:

A feeling, for example, may vary in intensity over a certain stretch of time, and it may change by gentle degrees or abruptly; or it may be interrupted by quite opposed or irrelevant feelings; it may fluctuate in a random way, at the mercy of shifts in the phenomenally objective field, or it may begin as one feeling among many and slowly spread over the whole field of awareness. It seems to me that the terms *continuity* and *discontinuity* apply quite clearly to such sequences, and continuity makes for coherence, in affects as well as in objects.[9]

I now believe that Beardsley is right in saying that feelings as such can be unified. For example, if a work of art evoked a feeling and sustained that same feeling throughout the performance of the work, then the affective content of the experience would be unified because it would consist of a single feeling. Again, if a work of art evoked a series of discrete feelings all of the same type, as say a horror movie might evoke a series of feelings of fright, then the affective content would be unified because the

[9] "Aesthetic Experience Regained," p. 7.

feelings would be all of the same type. Again, if a work of art evoked both sad and happy feelings in some pattern, then perhaps we could say that the set of feelings is unified by similarity and contrast. The fact that the feelings in some aesthetic experiences are unified does not mean, however, that they are unified in all such experiences. It is difficult to see how the great welter of feelings evoked by *Hamlet* or most works of art of much complexity fall together into an affective unity.

It is significant, I think, that Beardsley talks about music when he illustrates the existence of affective unity. Although music (the phenomenally objective sounds) is enormously complicated, the feelings it evokes (when it does evoke feelings) are usually relatively simple. For this reason and perhaps others, music seems to be able to sustain the same feeling over a considerable period of time and, consequently, music frequently produces the kind of affective coherence that Beardsley speaks of. Having agreed this far, however, I wish to suggest the possibility that just as some (good) paintings do not ordinarily produce feelings, that perhaps some (good) music also does not produce feelings.

Even in those cases in which I have agreed that there seems to be unity (coherence) of feelings, I feel a certain uneasiness. When one compares the many, clear, and easily verifiable ways in which the elements of music, poetry, and painting link up with one another to build up unified structures with the ways in which the affective elements of experience are supposed to link up, the vagueness of the notion of unified feelings becomes ap-

parent. Even so, Beardsley is probably right in thinking that it is possible for feelings to cohere.

Coherence is not the only kind of unity that affects may have, according to Beardsley; a set of affects may be complete. He says that the completeness of a work of art can produce an experience which is complete. In order to illustrate such completeness, he again talks of music. The affective elements which, according to Beardsley, go to make up a complete set are expectations and satisfactions of expectations. I can think of only one kind of case in which an expectation and a satisfaction would be a complete affective set caused by a work of art. This would be a case in which some occurrence in a work of art sets up an expectation, the expectation is sustained by subsequent occurrences, and finally at the end something happens which fulfills the expectation. In such a case, an affect that had spanned the entire duration of the performance of the work would have been satisfied and completed. But suppose a work, such as the kind of abstract painting I talked of earlier, sets up no expectations, then such a work cannot produce an experience which is complete in the sense Beardsley specifies. Or suppose that an occurrence in a work sets up an expectation E_1 which is subsequently fulfilled by satisfaction S_1, a later occurrence in the work sets up another expectation E_2 which is subsequently fulfilled by satisfaction S_2. In order for the affect pairs E_1/S_1 and E_2/S_2 to constitute a unity in the sense of being complete, the one pair would have to complete the other pair in some way. Each pair is complete—the second part of each pair completes the first

part of each pair, but the second pair does not complete the first pair. Both of the expectations and both of the satisfactions could be important aspects of the experience of the hypothetical work under discussion, so I am not challenging the importance of expectations and their satisfactions. I am challenging the view that a set of more than one expectation-satisfaction pairs constitutes a complete set. Of course, it is possible to have a work that causes two kinds of expectation-satisfaction pairs: one of the overarching kind, the satisfaction of which comes at the end of the work, and others aroused and fulfilled during the course of the work. In such a case the completeness of the experience would be due to the overarching expectation-satisfaction pair, not the other pairs.

If I am right, aesthetic experiences are more varied with regard to affective aspects than Beardsley envisions. There are aesthetic experiences in which the works of art experienced evoke no affects, either emotional or expectational. As I indicated earlier, I think that much of our experience of art is of this type. I suspect that the very old association in the philosophy of art of emotion and art, which begins with Plato, has conditioned us to ignore these "cool" aesthetic experiences when we come to reflect on the nature of aesthetic experience. This old theoretical association causes us to focus on the "warm" cases. (I should note that there is nothing "warm" about expectation and fulfillment, so the "cool-warm" classification does not fit in a completely neat way.) I have also tried to show that even in the cases in which works of art evoke affects that these affects are not always unified,

even when the experience is adequate to the work and the work is a good one. Aesthetic experiences which do contain affects come in a variety of kinds, some of which are unified and some of which are not. An experience might be a unified one that has coherent feelings but is noncomplete because no expectations are aroused. An experience might not be unified because although feelings are aroused, they do not cohere and no expectations are aroused. An experience might be a unified one that is complete because an expectation is fulfilled, but noncoherent because no feelings are aroused. An experience might not be unified because it arouses no feelings and an aroused expectation is not fulfilled. An experience might not be unified because although it arouses feelings and an expectation, the feelings do not cohere and the expectation is not fulfilled. An experience might be unified because although feelings do not cohere, an expectation is satisfied. An experience might be unified because although an aroused expectation is not satisfied, feelings cohere. Finally an experience might be unified because feelings cohere and an expectation is satisfied.

Given the considerations under discussion the following list illustrates the various kinds of aesthetic experience:

1. No feelings and no expectations
2. No feelings and expectations satisfied
3. No feelings and expectation not satisfied
4. Noncoherent feelings and no expectation
5. Noncoherent feelings and expectation satisfied
6. Noncoherent feelings and expectation not satisfied

7. Coherent feelings and no expectation
8. Coherent feelings and expectation not satisfied
9. Coherent feelings and expectation satisfied

I think that types of aesthetic experience 3, 6, and 8 in which expectations are aroused and then not fulfilled are in many instances defective as aesthetic experiences. I do not say defective in all cases because that would imply that surprise endings, which frustrate expectations, are always a defect. But if some noncomplete aesthetic experiences are somewhat defective, they are still aesthetic experiences. Remember that when Beardsley sets up the problem of the nature of aesthetic experience, he specifies or locates aesthetic experience in the following way: "The problem is whether we can isolate, and describe in general terms, certain features of experience that are peculiarly characteristic of our intercourse with aesthetic objects."[10] If I am right, the experiences that derive from intercourse with aesthetic objects do not have any affective features which are peculiarly characteristic and which distinguish them from other experiences. If aesthetic experience is to be distinguished from nonaesthetic experience (and if there is any point in drawing the distinction), it will have to be done by determining whether the object from which the experience derives is an aesthetic object or not.

Thus far in this chapter, and in the book generally, I have been concerned with the aesthetic objects of *works of art*. The question naturally arises: are there aes-

[10] *Aesthetics*, p. 527.

thetic objects of natural objects? If there are such objects, then, of course, there could be aesthetic experiences generated by them. In the last chapter when this issue momentarily raised its head, I said that works of art have an "inner life" which natural objects do not have and that in the case of natural objects we can appreciate whatever happens to "fall together." At that point I had not yet tried to show the importance of conventions and practices for the notion of the aesthetic objects of works of art. Speaking of the "inner life" of works of art was a way of referring to the conventional distinctions as to which of their aspects are properly appreciated and criticized and which are not. Natural objects lack this "inner life" because they are not embedded in the matrix of conventions in which works of art are. A visual natural object, for example, may have better and worse sides from which to view it because of, say, the colors of its various sides, and it will have directional sides (northerly, southerly), but it will not have a front and back as a painting does. Of course, people may speak of the back side of a mountain because it is the side which does not have road access or because it is the side that is not usually climbed, but this is different from speaking of the back of a painting, i.e., the side of a painting which conventionally is not viewed. One characteristic of a natural object is as properly a candidate for appreciation as any other of its characteristics; none of its characteristics enjoys the conventionally engendered status which the aesthetic aspects of works of art possess, although some of

a natural object's characteristics may be preferred be-
cause they are beautiful, sublime, and so forth.

I want to be cautious here. I am not saying that there
are no conventional aspects involved in the appreciation
of nature; there may well be some. If conventional as-
pects exist, however, they may be rather different from
the conventions involved in the appreciation of art or
they may be somewhat similar. If there are nature-ap-
preciation conventions, they may have relations to art-
appreciation conventions, and this possibility raises in-
teresting questions: Which came first? Did the two grow
up together? If one came first, does the later resemble
the earlier in any way? I shall, however, leave the discus-
sion of these interesting questions for another occasion
or for other persons.

Index

Art and the Aesthetic

Designed by R. E. Rosenbaum.
Composed by York Composition Co., Inc.
in 11 point linotype Janson, 3 points leaded,
with display lines in monotype Deepdene.
Printed letterpress from type by York Composition Co., Inc.
on Warren's No. 66 text, 60 pound basis,
with the Cornell University Press watermark.